THE PRICE OF FREEDOM

AMERICANS AT WAR

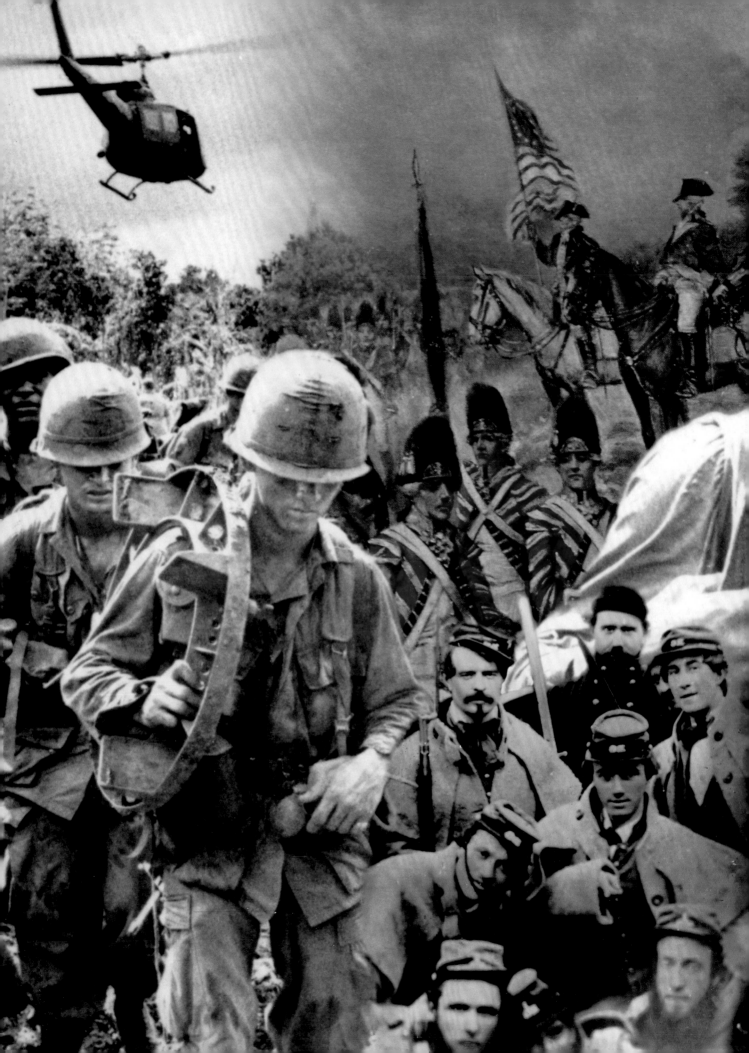

THE PRICE OF FREEDOM
AMERICANS AT WAR

Smithsonian Institution
National Museum of American History
Behring Center

Marquand Books, Seattle

Exhibition Foreword

On November 11, 2004, Veterans Day, the Smithsonian's National Museum of American History opened a permanent new exhibition *The Price of Freedom: Americans at War*. This 18,200-square-foot exhibit, located in the Kenneth E. Behring Hall of Military History, surveys the history of America's military from the colonial era to the present, exploring ways that wars have been defining episodes in American history. Using hundreds of original artifacts and graphic images, the exhibition tells how Americans have fought to establish the nation's independence, determine its borders, shape its values of freedom and opportunity, and define its role in world affairs. Because American wars have social as well as military impact, displays extend far beyond a survey of battles. They also describe the relationship between military conflict and American political leadership, social values, technological innovation, and personal sacrifice.

Within the walls of this expansive exhibition, visitors will have the opportunity to see many of the most prized objects in the Smithsonian's national military collection. They include uniforms of such leaders as George Washington, Andrew Jackson, George Custer, and Colin Powell as well as items ranging from a Lafayette cannon used during the struggle for American independence, to uniforms and weapons used by Civil War soldiers, a World War II GI barracks, the tail-gunner compartment of a B-17 bomber, and a UH-1 Huey helicopter that flew in combat during Vietnam. These military artifacts are augmented by objects from collections of political history, social history, and natural history, from the recently opened National Museum of the American Indian and the National Air and Space Museum, among others.

The exhibition includes an orientation theater and a concluding experience that focuses on sacrifices veterans make when they fight in America's armed forces. There is also a wide range of hands-on opportunities for young people and families, as well as interactive multimedia stations where visitors can hear first-person accounts of wartime experiences.

The National Museum of American History owes thanks to many people who contributed to the completion of this exhibition. First, we thank Kenneth E. Behring for the generous financial support that made the exhibition possible. Second, we recognize the exhibition team, which included members not only from our own staff, but also from across the Smithsonian Institution, particularly the National Air and Space Museum. Additional thanks are due to scholars from across the country and within the museum whose critiques improved the accuracy and interpretations in the exhibition text.

To understand American history, we must understand the American Dream, the values, ideals, and traditions that are woven through the story of America. Freedom, peace, and security are fundamental parts of the American Dream. In many respects, our military history reflects our commitment to these ideals as well as the beliefs of the men and women who have made enormous personal sacrifices—on the battlefields and on the home front—to achieve them.

Brent D. Glass
Director
National Museum of American History, Behring Center

Contents

PART I

Colonial Conflict and the Road to Independence

Wars erupted frequently in North America in the 1600s and 1700s. Imperial rivals Britain, France, and Spain clashed with each other and with resident Indians to establish footholds on the continent or to gain the upper hand in European-centered power struggles.

In 1754, Britain went to war to prevent French expansion into British-claimed territory in the Ohio River Valley. Provincial troops and citizen militias in the colonies took up arms; British soldiers were dispatched to America; and Indians joined the fighting on both sides. War soon broke out in Europe as well and raged for seven years. Britain won, adding Canada, Florida, and the Great Lakes region to its global holdings.

Following victory in the French and Indian War—known in England as the Seven Years' War—Britain looked anew at its imperial responsibilities and decided to secure its expanded American empire with British troops. When Parliament enacted and executed taxes and other binding laws without deference to colonial governments or popular consent, colonists protested and eventually fought the British to gain independence.

The French and Indian War

Colonial provincial troops and local militia fought the opening battles of the war against the French and their Indian allies. Colonials continued to fight when regular British soldiers under the command of General Edward Braddock were dispatched from England to conduct the war. After initial setbacks, including a British rout at the Monongahela River in which Braddock was killed, combined British forces successfully ousted the French from the Ohio River Valley in 1758.

Colonial Military Forces

British colonies raised provincial regiments and called out citizen militias to advance their interests—often against neighboring Indians. These local forces also saved Britain the trouble of dispatching large numbers of its own troops to the colonies. Provincial regiments were composed of long-term regional volunteers equipped by each colony. Militias were composed of local white men, and sometimes free black men, between the ages of sixteen and sixty who trained irregularly and were mustered, or called out, only as needed. They provided their own weapons. Throughout the war, the British disparaged colonial forces: Braddock's aide labeled them "languid, spiritless, and unsoldierlike in appearance."

Indians at War

Hundreds of thousands of Indians occupied North America. Their relationships with each other, and with Europeans, were based variously on trade, alliance, rivalry, and warfare. In 1754, the Iroquois were staunch British allies. Their rivals, the Huron and the Algonquin, allied themselves with the French. Indians saw the alliances as a way to play the Europeans against each other and against rival Indians in order to protect their own interests and autonomy.

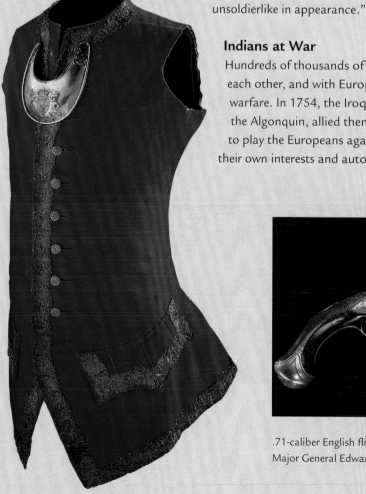

Waistcoat and gorget worn by Lieutenant Colonel Adam Stephen of the provincial Virginia Regiment. The gorget, a small ornamental plate decorated with the British coat of arms, was a sign of rank.

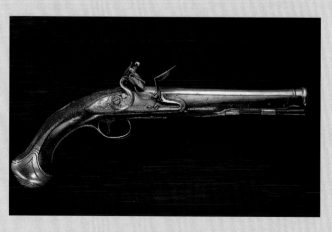

.71-caliber English flintlock pistol given to George Washington by Major General Edward Braddock.

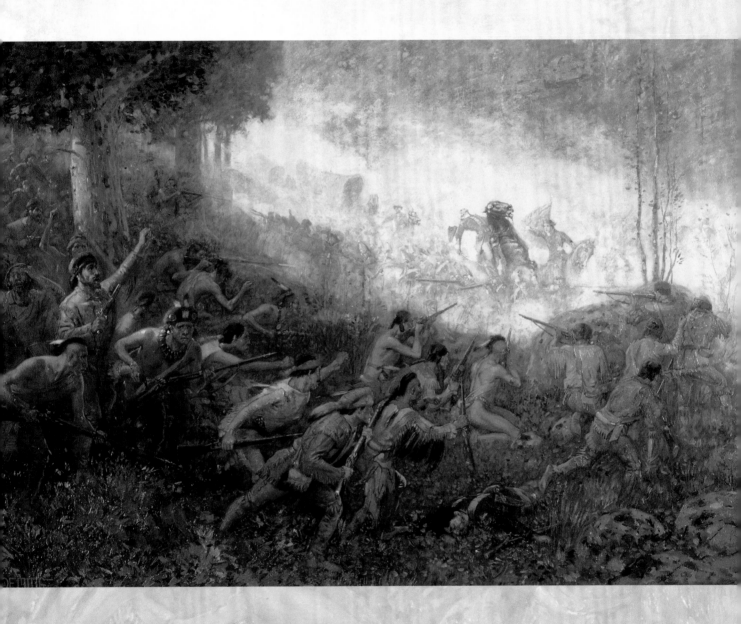

Braddock's Defeat

British troops under the command of Major General Edward Braddock were dispatched to Virginia in 1755. Twenty-three-year-old George Washington accompanied them on their first foray against the French and the Indians, which ended in a calamitous defeat near Pittsburgh. Braddock was killed, but Washington emerged from the fray acclaimed. The royal governor of Virginia named him commander of the colony's provincial regiment. For two years he oversaw the Virginia Regiment and attempted to secure a commission in the British army. In 1759, after helping defeat the French in the Ohio River Valley, Washington resigned. He was disillusioned with the British military's disparaging view of provincials and frustrated with commanding free-willed volunteers.

Braddock's Defeat, by Edwin Willard Deming, 1903.

The War of American Independence

Following its victory in the French and Indian War, Britain reversed a long-standing hands-off approach—"salutary neglect"—to administering the colonies in America. King George III and his government began to enact and enforce laws and taxes, bypassing the colonies' own English-styled representative legislatures, common-law jury courts, and local militias. Many considered this intolerable, and colonists protested. They issued statements of their rights, appealed to the king and people of Britain, petitioned Parliament, and boycotted British goods. As colonial resentment turned to open resistance, some protests became violent.

The Boston Massacre

When Britain stationed troops in Boston, many colonists feared that the king intended to rule by force of arms. Scuffles between soldiers and protestors became commonplace. On March 5, 1770, British soldiers fired into a crowd that had been pelting them with insults and snowballs. Five colonists were killed. John Adams, who defended the soldiers in court, portrayed the victims as "a motley rabble of saucy boys . . . and outlandish jack tars." Others saw them as patriots. Popular leaders pointed to the "massacre" as evidence that a standing army threatened American liberty and lives.

The Boston Tea Party

Brewing colonial resentments boiled over in response to trade regulations on tea. On December 16, 1773, about fifty men—some dressed as Indians—boarded ships in Boston's harbor and tossed chests of tea overboard. Parliament retaliated by closing the port of Boston, dispatching more troops, and suspending civilian government in Massachusetts. Other colonies rallied in support, dumping tea in several ports.

BELOW (LEFT TO RIGHT)
Paul Revere's 1770 propaganda print of the Boston Massacre showed a line of soldiers firing when an officer gave the order. This inaccurate portrayal was intentionally crafted to arouse public outrage.

The Boston Tea Party.

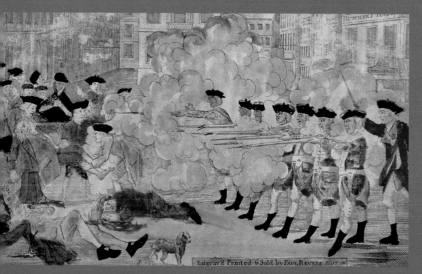

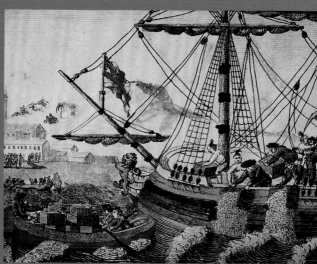

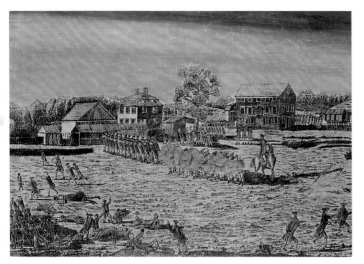

Amos Doolittle visited Lexington and Concord a few weeks after the battle and based his 1775 engravings on sketches "taken on the spot" and interviews with participants. The militia members called to the green in Lexington, Massachusetts, were neighbors, fathers and sons, cousins; at least one was a slave; some were old men, some were teens. They had come only to defend their "just rights and liberties" as English subjects.

The First Shots

On April 19, 1775, British troops in Boston marched in darkness toward nearby Concord to seize the local militia's cache of arms and gunpowder. Patriots from Boston alerted the countryside. At dawn, the British confronted a militia unit gathered on the green in Lexington. During the standoff, someone fired a shot. In a brief melee, eight colonists were killed and ten wounded.

From Lexington, British troops marched to Concord, where they destroyed the few supplies the militia had not hidden. After a fierce skirmish with militia, they started back to Boston. Hundreds of militiamen joined the counterattack, forcing the British to make a desperate retreat through a gauntlet of musket fire. Exhausted and panicked British soldiers lashed out, killing civilians, ransacking and looting houses, and setting fires. News of the fighting rallied "Friends of American Liberty" in all the colonies. The battles at Lexington and Concord marked the beginning of the War of American Independence.

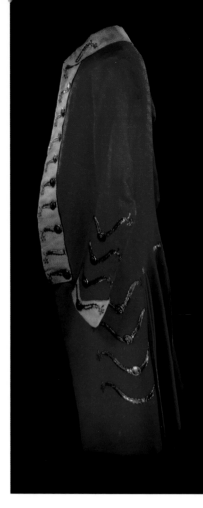

This red coat (circa 1768) was worn by British Loyalist Lieutenant Eli Dagworthy, son of Brigadier General John Dagworthy, of the Forty-Fourth Regiment of Foot. The red coat became the symbol of British influence and oppression in colonial America after the French and Indian War. Worn by the majority of the British army, the red coat was both feared and respected by Continental army forces. Capturing a coat was a much sought-after prize by American militiamen.

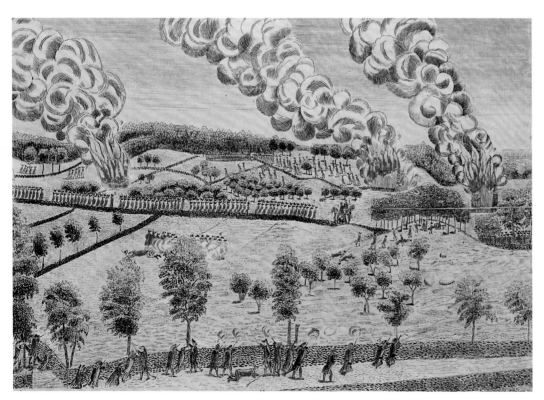

The Declaration of Independence

O n July 4, 1776, the thirteen colonies formally declared their independence from Great Britain. They pledged to join together as free and independent states in which all men were equal and empowered to govern themselves. And they proclaimed their inalienable right to life, liberty, and the pursuit of happiness. Men who owned no property, women, and Africans in America—both enslaved and free—were considered ineligible for these rights. But all Americans would seek to appropriate the cause of liberty as their own.

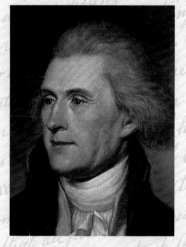

Thomas Jefferson, by Charles Willson Peale, 1791–92.

The Real Revolution

Just two decades before the American War of Independence, most residents of the colonies in America considered themselves British subjects—regardless of their class, ethnic, or economic differences. But a revolution of ideas changed the way Americans viewed the meaning and assurance of liberty, even their sense of themselves as American, not British, citizens. They no longer believed that a king should hold supreme power over the people. Instead, they proclaimed that the people themselves should be sovereign. "What do we mean by the revolution?" John Adams wrote to Thomas Jefferson in 1815, "The war? That was no part of the revolution; it was only an effect and consequence of it. The revolution was in the minds of the people, and this was effected from 1760 to 1775, in the course of fifteen years, before a drop of blood was shed at Lexington."

Thomas Jefferson

Only thirty-three years old when he drafted the Declaration of Independence, Jefferson was influenced by John Locke's "natural rights" philosophy. Jefferson expressed a principle that many Americans shared: government is a voluntary agreement between a ruler and the people.

RIGHT
The Declaration of Independence.

The Nation's Military

Just weeks after the outbreak of fighting at Lexington and Concord, delegates from every colony gathered in Philadelphia. In June 1775, the Continental Congress established a colonial military "for the Defense of American Liberty." They united the troops of the several colonies into a single Continental army and selected George Washington as its commander. They authorized a Continental navy in October and a contingent of marines in November. Most colonists harbored a deep distrust of a standing army, but the establishment of such a force was a necessary step toward creating a nation.

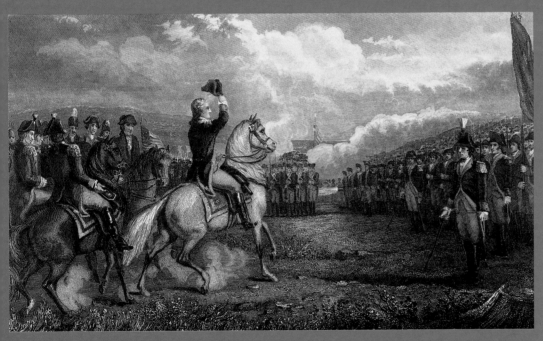

LEFT
A nineteenth-century depiction of George Washington taking command of the army at Cambridge, Massachusetts. For the next year and a half, outmatched American troops would engage the British in brief battles and quick retreats.

BELOW (LEFT TO RIGHT)
George Washington's camp chest and stool.

Fighting the War

M ost battles between the British and Continental armies were fought in traditional field encounters. Because muskets were inaccurate weapons—balls seldom flew straight from their smoothbore barrels—troops stood shoulder-to-shoulder and fired simultaneously at close range in traditional linear formations. Opposing armies exchanged volleys of lead shot that whistled through the air, then tore gaping wounds or shattered limbs intending to break up the enemy's lines and open the way for a bayonet charge. But throughout the colonies, unconventional confrontations also occurred. Partisan fighters in the South, for example, were intimately familiar with the swamps, savannahs, and pine forests of South Carolina and Georgia. They fought from tree to tree, shot while concealed, and advanced under cover. Some "over-the-mountain men" had deadly accurate, long-range rifled muskets. These backcountry fighters often resorted to hit-and-run tactics, ambushes, and ruthless take-no-prisoners combat but fought in traditional formations when teamed with the Continental army.

The Northern Campaign

Having failed to crush the rebellion in 1775 and 1776, the British planned a three-pronged attack for 1777 to divide and conquer the northern colonies. One force of British regulars, Iroquois allies, and loyalist militia (colonists who supported Britain) would march south from Canada toward Albany. A second army would push north from British-occupied New York City to meet them. A diversionary force would invade western New York.

In August 1777, American forces at Fort Stanwix repulsed British, loyalist, and Indian troops invading western New York. In September, British troops in Manhattan were sent south to Philadelphia. And in October, Continental troops reinforced with large numbers of local militia and Indian allies stopped the British advance at Saratoga. The British suffered 1,200 casualties to the Americans' 470—nearly 5,000 redcoats surrendered and most were held as prisoners of war until 1783.

ABOVE (LEFT TO RIGHT)
Coat worn by Colonel Peter Gansevoort, who commanded American forces at Fort Stanwix.

The tricorn hat, emblematic of early America.

Depiction of the British surrender at Saratoga by Percy Moran, 1911. In this painting, General Horatio Gates accepts the surrender from British General John Burgoyne. Instrumental to American victory was the heroic leadership by General Benedict Arnold and the skillful sharpshooters of Colonel Daniel Morgan.

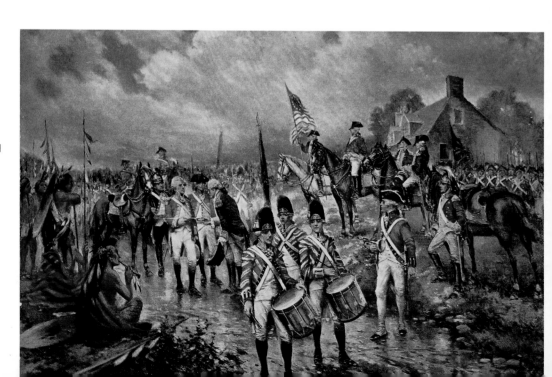

Benjamin Franklin

From humble beginnings, the "folksy" Franklin rose to wealth and fame beyond nearly all colonial Americans. To many, he came to represent the "American Dream." Franklin spent more time in Europe—first England and then France—than any other founder and played a remarkably significant role in the achievement of American independence. Ironically, it was not until 1775 that this near-seventy-year-old Royalist became convinced that independence for America was both warranted and inevitable. This late change in philosophy did not inhibit his ardent patriotism both during and after the war.

Following the decisive American victory at Saratoga, Franklin, acting as America's representative in Paris, negotiated a treaty with France in which they openly declared support for and recognized America as an independent nation. France, Holland, and Spain provided troops and warships and challenged Britain worldwide, transforming the war for American independence into a global war that Britain could not win. Franklin was essential to the success of the American Revolution abroad.

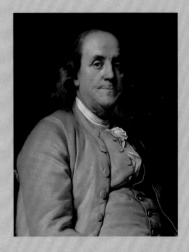

Benjamin Franklin, by Joseph Siffred Duplessis, circa 1785.

The War in the South

British operations in the South were initially successful. In 1778, British troops captured Savannah, Georgia, and moved inland. In 1780, they captured Charleston, South Carolina, taking six thousand prisoners. But when British forces attempted to move beyond the coast, their progress was slowed by repeated clashes with Continental troops and local partisan militias.

A Civil War

Much of the fighting in Georgia and the Carolinas took place between Americans. One in five colonists remained fiercely loyal to the Crown. Some were wealthy aristocrats; most were farmers or tradesmen. Some took refuge in British strongholds in Charleston, South Carolina, or fled to Canada, the Caribbean, or England. Many others fought as members of loyalist units.

General Nathanael Greene

Greene commanded the southern department of the Continental army. In an often tense partnership with partisan leaders Thomas Sumter ("the Gamecock"), Andrew Pickens ("the Fighting Elder"), Francis Marion ("the Swamp Fox"), William Harden, and others, Greene continually frustrated the British. Even though he never won a major battle, his Fabian tactics helped to assure victory in the war.

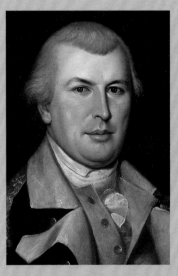

General Nathanael Greene, by Charles Willson Peale, circa 1780.

Indians as Allies

The peoples of the Iroquois Confederacy fought on both sides during the war. At the outset, the six Iroquois nations pledged their neutrality: "We are unwilling to join on either side of such a contest," declared the Oneida in 1775, "for we love you both—old England and new." But shortly afterward, the Mohawk and most other Indians sided with Britain; the Oneida and the Tuscarora sided with the patriots.

Victory at Yorktown

Surrender of Cornwallis at Yorktown by John Trumbull, 1787. Mortified by events, Cornwallis sent his second in command, Charles O'Hara, who turned over the surrender sword to Benjamin Lincoln, Washington's second in command.

I n August 1781, General George Washington was monitoring British activity in New York City when he learned that the French fleet was sailing to the Chesapeake Bay. A large British army had retreated from the southern interior and now occupied Yorktown, Virginia. Washington and Comte de Rochambeau, commander of French forces in America, saw a fleeting opportunity to entrap them. They rushed south.

The Siege

While the French fleet commanded by Admiral Comte de Grasse blocked the Chesapeake and held the British fleet at bay, American and French troops trapped British forces at Yorktown in the fall of 1781. They bombarded the town relentlessly and, in bold assaults, captured important outlying positions. Fierce British counterattacks proved fruitless. On October 17, the British commander Lord Charles Cornwallis accepted a humiliating reality: his position was untenable. He had no choice but to surrender. Two days later, the articles of surrender were signed and independence was assured.

"The World Turned Upside Down"

The British surrendered more than seven thousand troops at Yorktown. Yet they remained in control of New York and Charleston, and continued limited fighting in the colonies and abroad for another year. Once news of the surrender reached London, popular support for the war vanished. This disaster, together with other setbacks at home and abroad, led to the downfall of Prime Minister Lord North. Britain opened peace talks with American diplomats in Paris.

French engraver's depiction of the British surrender at Yorktown, 1781.

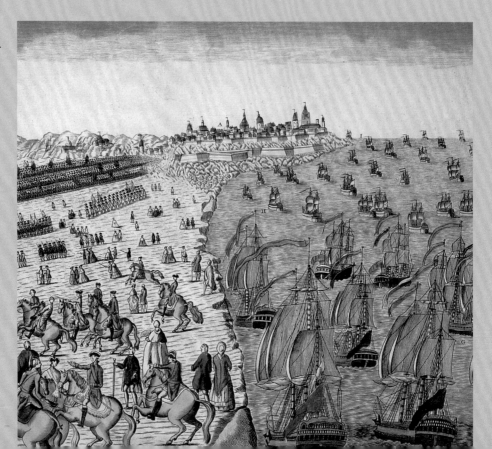

The Treaty of Paris

The war formally ended in a Paris hotel room on the morning of September 3, 1783, when both sides signed a treaty pledging "to forget past Misunderstandings & Differences." The treaty recognized the colonies as the United States of America, established boundaries, and guaranteed that both nations would enjoy free passage on the Mississippi River.

When news of the signing reached America, the British army evacuated New York and Charleston. Washington resigned his military commission, and Congress abolished the Continental army, navy, and marines, retaining only eighty privates and a few officers to guard surplus arms and equipment.

Candlesticks from the room where the treaty was signed.

The last page of the Treaty of Paris, signed by D. Hartley, John Adams, Benjamin Franklin, and John Jay.

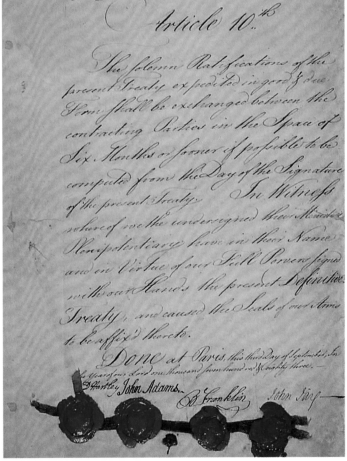

George Washington's Legacy

First in war—first in peace—and first in the hearts of his countrymen, he was second to none in the humble and endearing scenes of private life; pious, just, humane, temperate and sincere; uniform, dignified and commanding; his example was as edifying to all around him as were the effects of that example lasting.

—Congressman Henry Lee's eulogy to George Washington,
December 14, 1799

D uring the war, George Washington saw himself and his army as agents of the Continental Congress. He deferred to its directives even when he disagreed with them, affirming an enduring American principle: the military serves under civilian control.

Newburgh Conspiracy

BELOW (LEFT TO RIGHT)
A Display of the United States of America, by Amos Doolittle, 1788–89.

Uniform worn by Washington from 1789 to 1799; none of the uniforms he wore during the war survive.

In 1783, some of Washington's officers in Newburgh, New York, became angry when the Congress repeatedly delayed their pay and deliberated changes to pensions. A small group conspired to stage a mutiny and march against Congress. Washington opposed them. He upbraided his officers, appealing to their sense of duty and reminding them that he himself had grown gray in their service. In averting any rebellion, Washington ensured that America's military remained subordinate to civilian authority.

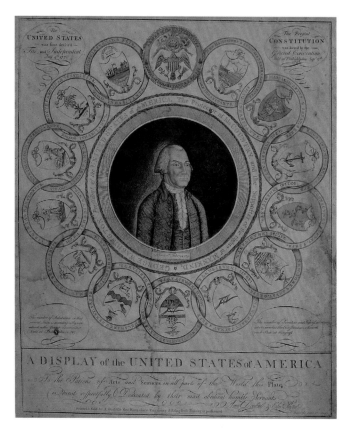

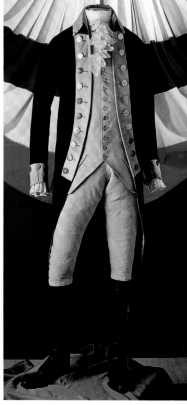

General George Washington Resigns His Commission as Commander in Chief of the Army, by John Trumbull, 1924.

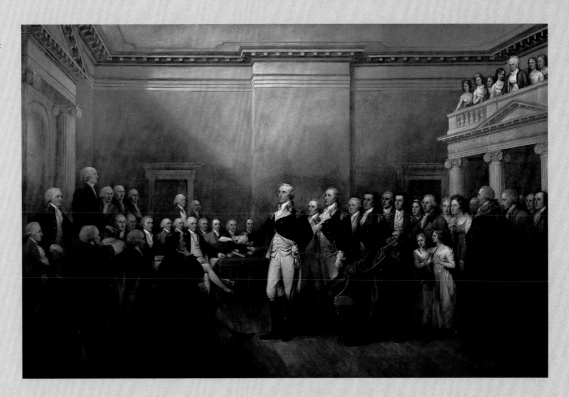

George Washington's battle sword and scabbard. The sword has a slightly curved, grooved steel blade. The green ivory grip is decorated in silver. The scabbard is leather. Washington wore the hanger-type battle sword while he was commanding the Continental army. He later bequeathed the sword to his nephew, admonishing him to draw it "only in self defense or in defense of the country and its rights."

Years after the war, Washington wrote: "It was known that the resources of Great Britain were, in a manner, inexhaustible, that her fleets covered the ocean and that her troops had harvested laurels in every quarter of the globe. Not then organized as a nation, or known as a people on the earth, we had no preparation. Money, the nerve of war, was wanting. The sword was to be forged on the anvil of necessity."

Washington Stands Down

A triumphant general in Washington's position might have tried to seize power, but Washington returned to private life. On December 23, 1783, he appeared before the Congress meeting in Annapolis, Maryland, and surrendered his commission as general and commander in chief. Per order of Congress, he signaled his deference to the members by bowing; in return, they denoted their authority by only lifting their hats. Washington then bid them farewell and returned to his farm in Virginia.

A New Nation

In 1789, a new constitution delineated structures and functions of a federal government and strengthened the foundation for a government of law. After spirited public debate, and an agreement to add amendments protecting individuals' liberties and states' rights, eleven states ratified the Constitution in 1787 and 1788; the last two joined them in 1789 and 1790. On April 30, 1789, Washington became the first president of the United States.

A New Commander in Chief

Under the Constitution, the president was commander in chief of the army and navy. Washington initially saw his role as that of a general: he took to the field with troops when farmers in western Pennsylvania challenged a federal tax on whiskey. But ultimately he established the convention of commanding the military as a civilian.

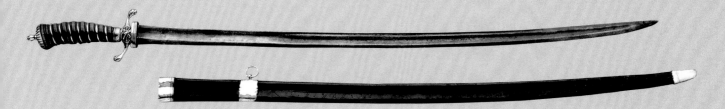

PART II

Westward Expansion

When George Washington served as first president of the United States, it was a nation of thirteen states arrayed along the eastern seaboard of North America. But settlers were already moving westward and were anxious to make the country grow. During the nineteenth century, the United States expanded across the North American continent and also acquired territories in the Caribbean and the Pacific. Some new land was obtained through negation or purchase, such as the acquisition of Louisiana from France; other land came through the victories of war.

The Louisiana Purchase

When Thomas Jefferson became president in 1801, the United States extended to the Mississippi River. The Indian-occupied land that stretched westward to the Rocky Mountains was claimed by France and called Louisiana. In 1803, faced with losing the territory to rival Britain, Napoleon offered to sell it to the Americans. Jefferson jumped at the chance. He negotiated the purchase of Louisiana from France for $15 million, doubling the size of the country. The purchase gave the nation control over the continent's central waterways, kept Spanish-claimed territories to the west at a safe distance, and provided Jefferson a place to relocate eastern Indian tribes, thus opening their lands to white settlement.

Jefferson dispatched Captain Meriwether Lewis, his personal secretary and a U.S. Army officer, to jointly lead an army expedition into the Louisiana Territory with Captain William Clark. This Corps of Discovery departed Saint Louis, Missouri, in 1804 with some two dozen soldiers, a few interpreters, and a slave. They returned in 1806, failing to find a water route to the Pacific but having made the first official overland expedition to the Pacific Coast and back.

BELOW (CLOCKWISE FROM TOP LEFT) Compass used by Meriwether Lewis and William Clark during their expedition.

Lewis and Clark carried peace medals to give as gifts to the Indians. The medal is made from two die-struck pieces of silver, with Jefferson on one side and a peace symbol on the other. The Indians used the medals as passports when visiting Washington, D.C.

One important result of the Lewis and Clark expedition was improved maps. This 1814 map by British cartographer Aaron Arrowsmith includes details he added following the return of the Corps of Discovery.

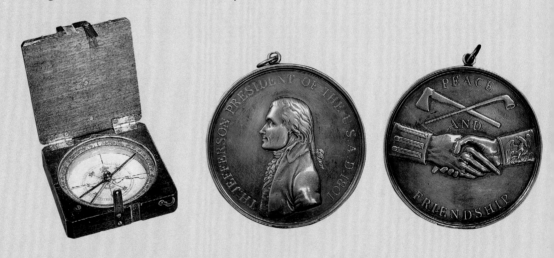

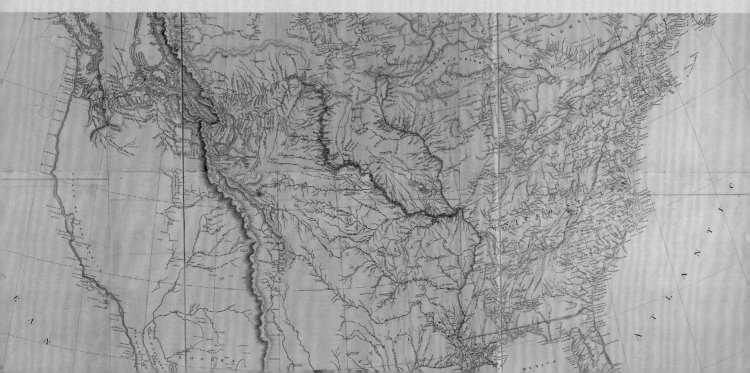

The War of 1812

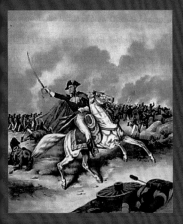

General Jackson—At the Battle of New Orleans, by Charles Severin, 1856.

The United States fought Britain in the War of 1812 to assert its rights as an independent, sovereign nation. During the Napoleonic Wars of the early nineteenth century, the United States remained neutral and traded with both Britain and France. Ignoring this stance, Britain harassed American shipping and impressed American sailors, making them serve on British ships.

In June 1812, the United States declared war and invaded Canada. American privateers and navy ships fought doggedly against British vessels. The English burned much of Washington, D.C., including the White House, then tried, but failed, to seize Baltimore Harbor. The United States gave up efforts to occupy Canada. Both Britain and America were ready for peace in 1814.

Andrew Jackson: A New Hero

The fight for Louisiana was the last major battle of the war. Britain brought some ten thousand of its best troops to seize New Orleans. To stop them, General Andrew Jackson had a force of four thousand composed of soldiers, militia, Choctaw Indians, former slaves, and even pirates. By carefully choosing his ground, Jackson forced the British to make futile attacks on well-fortified positions and defeated them in a lopsided victory. Added to his fame as an Indian fighter, this brilliant action propelled him to national prominence and ultimately to election as president in 1828.

LEFT TO RIGHT

Jackson wore this uniform, sword, and scabbard during the battle of New Orleans. At the time, Jackson was commander of the Seventh Military District, which included Louisiana, Tennessee, and the Mississippi Territory.

On September 13, 1814, British forces attacked Fort McHenry in Baltimore Harbor (shown here). After twenty-five hours of bombardment, they failed to take the fort. Watching the battle while detained on a British ship, American lawyer Francis Scott Key wrote a poem that was set to music and eventually became the national anthem of the United States.

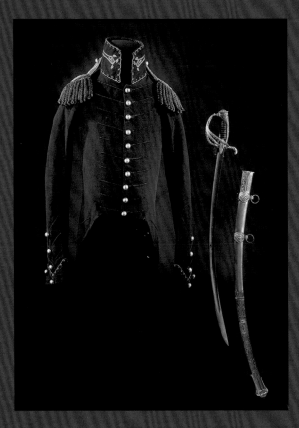

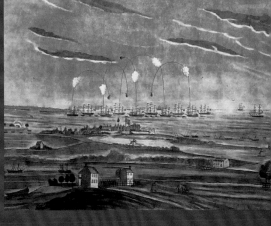

Eastern Indian Wars

During the War of 1812, one faction of the Creek Indians sided with the British and fought the United States along the western frontier. This group, known as the Red Sticks because of the bright-red war clubs they carried, followed the teachings of the charismatic Shawnee known as Tecumseh. They believed that Indians of many tribes needed to unite against the United States. On August 30, 1813, the Red Sticks attacked Fort Mims in the Mississippi Territory, where, in a bloody massacre, they killed between three hundred and four hundred people including militiamen, women, and children. Andrew Jackson would soon avenge the loss in the battle of Horseshoe Bend, on March 27, 1814. There, with a force of Tennessee militia, army troops, Cherokees, and White Stick Creeks, Jackson trapped the Red Sticks and slaughtered them, ending the Creek Indian War. In the treaty that followed, the Creek lost twenty million acres of land, half of all they claimed.

Indian Removal

After the War of 1812, the United States began systematic removal of many Indian tribes to western lands. Indian tribes no longer posed a serious military threat to white settlers. Still, most whites believed they could not live peacefully with the Indians. Those Indians who did try to assimilate often suffered severe discrimination. White settlers coveted Indian land, and conflicts were common. Federal and state governments were unable or unwilling to defend the terms of Indian treaties. President Jackson ultimately decided that the best solution to the issue was moving the Indians to new lands in the West. Although many opposed this position, it became government policy.

The Battle of Horseshoe Bend.

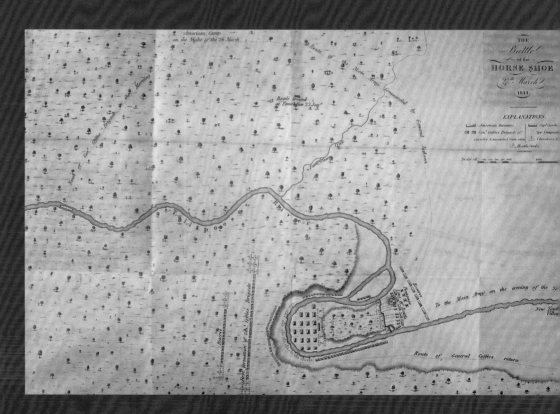

.28-caliber percussion pistol made in 1843 by Cherokee blacksmith Salolinita ("Little Squirrel").

In 1829, prospectors discovered gold in northern Georgia on land that the Cherokees had long controlled. The gold strike was a major reason for whites demanding the eviction of the Cherokees.

Cherokee deerskin fringe coat, 1800–1820.

The *Cherokee Phoenix* was the first American Indian newspaper. Edited by Elias Boudinot, it began publication in 1828.

A "Civilized" People

Many white people believed that Indians were incapable of cultural change. The Cherokees proved them wrong, however. Their leaders saw value in the technology and culture of their white neighbors and successfully adopted their methods of farming, weaving, and home building. They created their own constitution and government. Some attended white schools. In 1821, Sequoyah developed a written version of the Cherokee language. In 1828, the tribe began publishing a newspaper, the *Cherokee Phoenix*. These dramatic developments won the admiration and support of many Americans, particularly in the Northeast.

Trail of Tears

In 1838, General Winfield Scott and U.S. Army troops began removing the remaining Cherokees in the South to present-day Oklahoma. This process, known ever since as the Trail of Tears, is among the most tragic episodes in American history. Men, women, and children were taken from their homes, herded into makeshift shelters, and forced to march or travel by boat over a thousand miles during a bitter winter. About four thousand Cherokees died during the journey. They were one of five major tribes forced to move west.

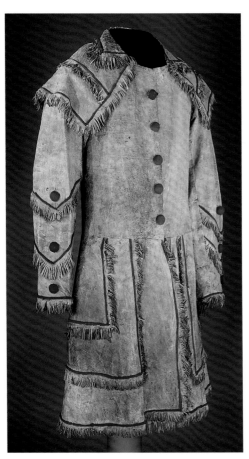

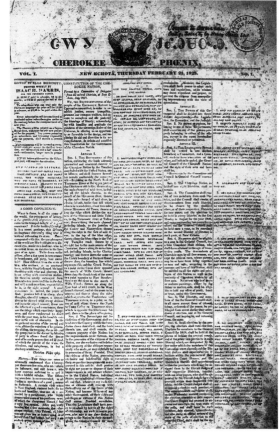

The Mexican War

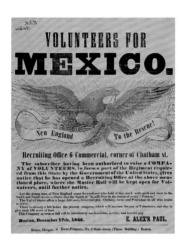

This 1846 broadside was used to recruit the "young men of New England" to fight in the Mexican War.

From 1846 to 1848, the United States fought Mexico to acquire land stretching from Texas to the Pacific Ocean. The war was largely a consequence of Texas's struggle for independence from Mexico and its annexation to the United States in 1845.

Manifest Destiny in Action

President James K. Polk came into office in 1845, determined to acquire additional territory from Mexico. He believed that obtaining the sparsely populated Mexican land that stretched from Texas to California was critical to the future of the United States. The president hoped to purchase, not conquer, the land, but Mexico rebuffed his advances. Polk ordered American troops under Zachary Taylor to march to the Rio Grande River. Violence erupted, and Polk, claiming that Mexico had fired first, asked Congress to declare war. Many Americans, including Illinois congressman Abraham Lincoln, opposed the war and questioned whether the fight began on American soil, but Polk prevailed.

To fight Mexico, the United States had to mobilize, equip, and transport a large force, including both army and navy components. President Polk planned a complex campaign. He sent one army under Stephen Kearny to capture New Mexico and then march on to California.

Mexican flag captured by the Baltimore and Washington Battalion of the U.S. Volunteers.

Commodore John D. Sloat assaulted California from the sea. Zachary Taylor attacked the main Mexican force from the north with a second army. Battles were hard and marches long. All three thrusts succeeded. Taylor won at Palo Alto and Saltillo. Kearny quickly captured Santa Fe, while the navy and army succeeded in California. Junior officers were of great importance—many had trained at the Military Academy at West Point.

Despite losses in New Mexico, California, and on its northern front, Mexico refused to surrender. To finish the war, President Polk followed the advice of his general in chief, Winfield Scott, and sent an army to capture Mexico City. He chose Scott himself to make an amphibious landing at Veracruz and then follow the path Hernando Cortés had taken centuries earlier when he defeated the Aztecs. Scott planned and executed a brilliant campaign, in which he consistently defeated larger forces through superior tactics and bold maneuvers. The Treaty of Guadalupe Hidalgo in 1848 ended the war.

Cultural Integration

Many Mexicans who lived in the territory lost to the United States decided to stay and become American citizens. Integration proved difficult, however. The U.S. government refused to accept land claims based on tradition or limited documentation, and many Mexicans lost their holdings. The California gold rush accelerated the growth of white settlement. Attitudes of the new arrivals conflicted with Mexican lifestyles and a strong Catholic faith. Despite this, earlier traditions survived and made the resulting culture of the West distinctly different from that of the eastern states.

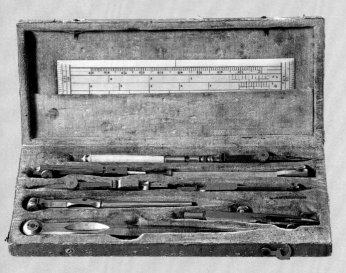

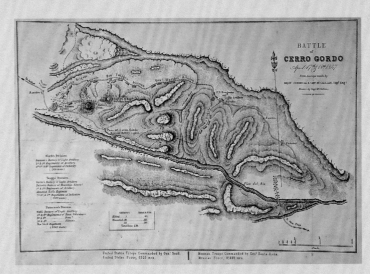

Drafting kit owned by West Point cadet George B. McClellan and used for mapmaking. Maps created by West Point graduates often made the difference between winning and losing a war.

At Cerro Gordo, General Winfield Scott demonstrated his effective leadership. Instead of assaulting a larger Mexican force head-on, Scott had his engineers carefully survey and map the area. They helped him find high ground, attack the enemy from two directions, and win the battle.

LEFT
Gold medal presented to Winfield Scott by the U.S. Congress in 1848 for his service in the Mexican War.

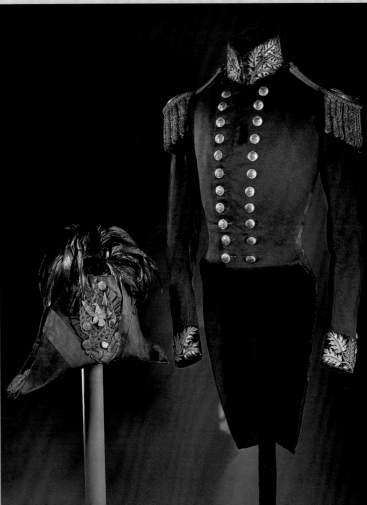

ABOVE AND RIGHT
After the war, Mexicans sometimes used traditional hand-drawn maps like this one of Rancho Miguelito to justify land claims to the U.S. government.

Chapeau and wool dress-uniform coat of the Corps of Topographical Engineers.

Western Indian Wars

After the Civil War, thousands of Americans headed west. The 1862 Homestead Act opened vast areas of government land for settlers to claim. Opportunities abounded for farming, ranching, and mining. In addition to easterners, the pioneers included numerous immigrants from Europe and freedmen from the South. This rush of new settlers put great pressure on the Indian tribes in the West, threatening their land, their game, and their way of life.

Battle of Little Bighorn

On June 25, 1876, at Little Bighorn—known to Indians as Greasy Grass—the U.S. Army suffered its greatest loss during the western Indian Wars. The army sent some sixteen hundred troops, including the Seventh Cavalry, to trap a large group of roaming Lakota Indians and force them onto a reservation. The plan was to attack simultaneously from three sides. However, Lieutenant Colonel George Custer, who led one body of troops, thought he had enough men to defeat the Indians alone. He divided his six hundred troops into thirds and attacked. The Indians greatly outnumbered Custer and defeated each group in turn, killing Custer and more than two hundred others. The loss so outraged the government that it mounted a new offensive that finally crushed armed Lakota resistance.

Geronimo

Geronimo and his band of Chiricahua Apache fought government domination longer than any other group of Indians. In the 1870s, the United States forcibly moved the Chiricahua to an arid reservation in eastern Arizona. Geronimo resisted at first but was caught and seemingly became resigned to reservation life. In 1881, however, he and his band escaped and began raiding settlements in the United States and Mexico. Until his final surrender in 1886, Geronimo would at times agree to stay on the reservation, and then flee with marauding warriors. He became infamous in sensational press reports. In the final campaign against him, the army needed Apache scouts plus more than five thousand soldiers to hunt him down.

LEFT TO RIGHT

Campaign hat worn by Indian scouts. The U.S. government regularly used Indian scouts to help them track other Indians.

This .45-caliber First Model Schofield Smith & Wesson revolver was found on the battlefield at Little Bighorn.

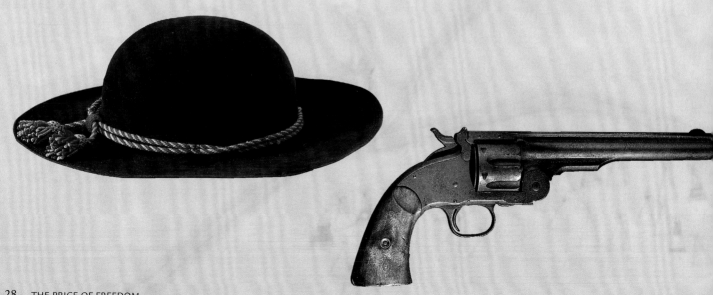

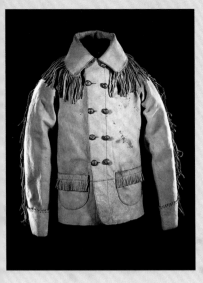
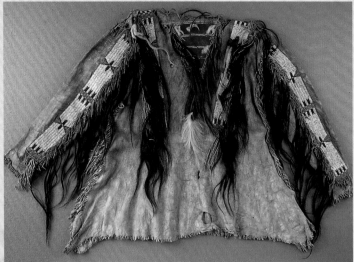
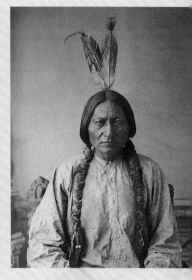

ABOVE (LEFT TO RIGHT)
George Custer's buckskin jacket.

Lakota Sioux ceremonial shirt.

Sitting Bull, Lakota Indian chief, 1877. "Look at me and look at the earth. It was our father's and should be our children's after us. . . . If the white men take my country, where can I go? I have nowhere to go. I cannot spare it, and I love it very much. Let us alone."

BELOW (LEFT TO RIGHT)
Indian wars service medal awarded to Lieutenant General Nelson A. Miles, who led the force that finally captured Geronimo.

Map of Indian reservations, 1892.

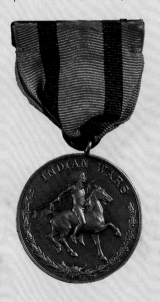

Wounded Knee

Stirred by a spiritual revival centering on the Ghost Dance, a group of Lakotas left their reservation in South Dakota. On December 29, 1890, as they returned to surrender, a scuffle broke out. Hearing a shot, soldiers fired, killing more than two hundred men, women, and children—the last to die in the Indian Wars.

Reservation Policy

In the late nineteenth century, federal policy changed from supporting separate Indian reservations to accelerating assimilation. The U.S. government wanted Indians to learn skills and attitudes needed for successful American citizenship. Indian children, seen as the key to assimilation, were forcibly taken from their homes and sent to school. In 1887, the government instituted the Dawes Act to accelerate assimilation by dissolving the reservations and allotting land to individual Indians. Most tribes resisted, refusing to give up their culture and unique way of life.

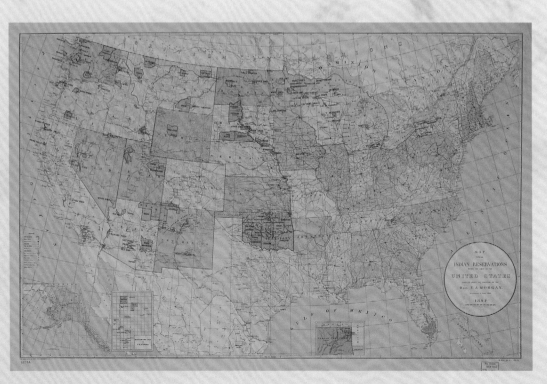

The Spanish-American War

Following the Civil War, the United States neglected its navy. By 1880, the U.S. Navy ranked twelfth in the world. Although the United States had no overseas colonies to protect, business and government leaders realized that a strong navy was essential to defend trade and growing international interests. Beginning in 1881, Congress supported a modernization program focused on ships with steel hulls, steam engines, and large, rifled guns. By the 1890s, the U.S. Navy had become a leading naval power.

The War in Cuba

On February 15, 1898, a mysterious explosion sank the battleship USS *Maine* in Havana Harbor, triggering a war between the United States and Spain. The *Maine* had come to Cuba to protect American citizens while Cuban revolutionaries were fighting to win independence from Spain. The United States supported their cause and, after the *Maine* exploded, demanded that Spain give Cuba freedom. Instead, Spain declared war, and America quickly followed suit.

As the war began, Spanish admiral Pascual Cervera concentrated his small squadron in Santiago Bay to help protect the forts. The U.S. Navy trapped the squadron when it blockaded Santiago along with other major Cuban ports. Cervera tried to break out early on July 3, but all of his ships were destroyed.

Like the naval campaign, the land campaign in Cuba centered on Santiago. On July 1, 1898, General William Shafter attacked the San Juan heights that overlooked the city. In a series of fierce engagements, the Americans pushed the Spanish off the hills. Having suffered heavy losses, the

BELOW (TOP RIGHT)
Theodore Roosevelt on horseback with the Rough Riders.

BOTTOM
Homemade Filipino rifle used by guerillas.

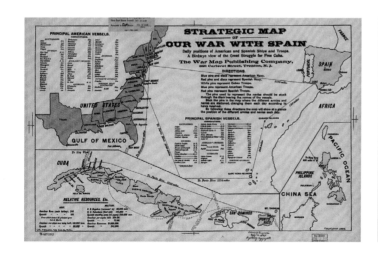

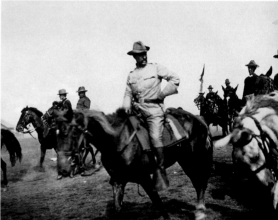

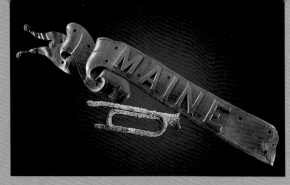

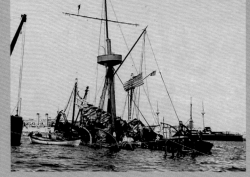

Americans then besieged Santiago rather than attack it further, and it fell on July 17. Spain then conceded defeat in Cuba. Following the victory, the person who attracted the greatest public attention was not General Shafter but Theodore Roosevelt, a flamboyant "Rough Rider" who had raced up San Juan Hill.

The War in the Philippines

As soon as the United States declared war on Spain, Commodore George Dewey took his Asiatic squadron from Hong Kong to the Philippines. On May 1, 1898, he decisively defeated the smaller Spanish squadron in Manila Bay. Winning on land took longer. The United States relied greatly on assistance from Filipino revolutionaries led by Emilio Aguinaldo, who already controlled much of the countryside and had proclaimed a Philippine republic. American troops did not arrive in large numbers until July. With the Filipinos, they negotiated Spain's surrender of Manila in August, as the war ended.

Becoming an International Power

Instead of liberating the Philippines from Spanish domination, the United States chose to annex the islands and begin building an American empire. Following the fall of Cuba, the army seized Puerto Rico. Samoa, Guam, and Wake Island also came into American possession, followed by Hawaii. In years to come, Americans would remain divided over the nation's imperial ambitions.

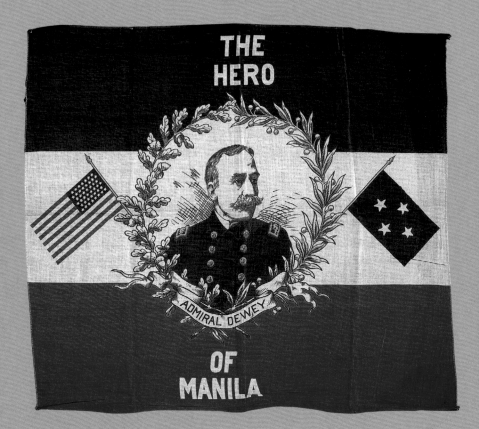

PART III

The Civil War

Divisions over the presidential election of 1860 precipitated the Civil War, completing a break that had been emerging for decades. Dramatic growth in wealth and population in the United States during the early nineteenth century had magnified differences between the free states and the slave states. Although most families in the North still farmed, the region's economy increasingly depended on capital investments in textile production, transportation, and manufacturing. Laborers worked for wages. In the South, the principal investments were in the human capital of slaves and the large-scale agriculture they made possible. Although most free Southerners did not own slaves, the economy and political power of their region depended on those who did. These divergent economic paths strained the political bonds that had held the two regions together in one nation. When Republican Abraham Lincoln was elected president in 1860, seven Southern states seceded from the Union, a step that led to war.

BACON'S
MILITARY MAP OF THE
UNITED STATES
Shewing the
FORTS & FORTIFICATIONS.

Published by BACON & Co 48 Paternoster Row
LONDON 1862

EXPLANATION

Free or Non Slaveholding States
Population 18,000,000 Area 1,823,437 Square Miles
Border Slave States
Popn 3,000,000 500,000 are Slaves Area 464,424 do
Seceded or Confederate States
Popn 10,000,000 3,500,000 are Slaves Area 833,144 do

A House Divided

North

President Abraham Lincoln

Lincoln assumed the presidency with little preparation for leading his country into war. He began his term in office with a limited mandate, having won only 40 percent of the popular vote, and no Southern states. Lincoln was a highly skilled lawyer and politician, but he had little military experience. He assembled a strong cabinet and committed himself to preserving the Union, by force if necessary. At his inauguration, he proclaimed to the South: "You have no oath registered in heaven to destroy the Government, while I . . . have the most solemn one to 'preserve, protect, and defend it.'"

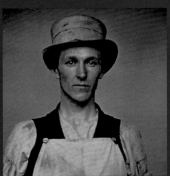

Industrialists

Many Northerners wanted the federal government to support the growth of American industry and manufacturing and to expand railroad and canal networks. They wanted higher tariffs on imported goods to protect U.S. industry. And they wanted to expand western settlement. Southerners opposed federal expenditures for internal improvements that bypassed their region. They opposed high tariffs that would hamper the sale of their cotton and tobacco overseas. And they did not want to see a growth of free states in the West that would dilute the power the slave states enjoyed in the U.S. Congress.

Free Laborers

Although many in the North were small farmers or tradesmen, growing numbers—especially immigrants and free blacks—found work in expanding urban centers. Many labored in clattering textile mills and steam-powered factories. Most worked twelve-hour days under trying conditions, earned meager wages, and lived with few comforts. Nevertheless, they prized their freedom and hoped that self-discipline and hard work would lead to a better life. When war came, many from this class fought to preserve the Union—some were drafted, others volunteered.

Abolitionists

A small but vocal minority in the North, abolitionists were Christian reformers, women, free blacks, and fugitive slaves. Appalled that the "land of the free" was the world's largest slave-holding nation, they advocated federal intervention to rid the nation of what they considered a moral evil. More numerous were the "Free-Soilers," who were willing to leave slavery alone in the South but opposed its spread to new territories. Together these groups formed a growing antislavery movement. With the outbreak of war, they demanded that it be a war of emancipation.

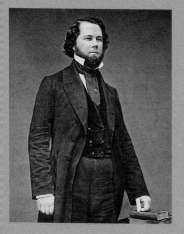

South

President Jefferson Davis
Davis had extensive military experience before he assumed
the presidency of the new Confederate States of America.
A graduate of West Point, he had fought Indians for several
years along the frontier and later served with distinction in the
Mexican War. He had experience in Congress as both a representative
and senator, and he had been secretary of war under President Franklin Pierce. When he was
inaugurated as president of the Confederacy, Davis expressed his hope that separation from
the Union would come peacefully. But he warned: "If this be denied to us . . . it will but remain
for us, with firm resolve, to appeal to arms."

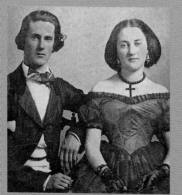

Planters
On the eve of the Civil War, the South's agricultural economy was booming. Cotton accounted
for three-fourths of the nation's exports. Planters depended on slave labor to maintain their
profit margins. Some even argued that slavery was morally superior to the wage-labor system in
the North. "Your whole hireling class of manual laborers . . . is essentially slaves," wrote James
Hammond, a South Carolina planter. "The difference . . . is, that our slaves are hired for life and
well compensated . . . yours are hired by the day, not cared for, and scantily compensated."

Farmers
Of the total Southern white population of eight million in 1860, only 384,000 owned slaves, and
more than 80 percent of these had fewer than twenty. Still, the slave system dominated economic
activity and shaped Southern culture. Small farmers shared many of the racial and political views
of plantation owners. Southerners felt a strong allegiance to their states and region and shared
the fear that they were in danger of being dominated by Northern interests. When war came,
many were willing to fight to save what they considered their unique way of life.

Slaves
Most slaves labored in fields of rice, sugar, tobacco, and cotton. Others were household workers
or skilled artisans—blacksmiths, carpenters, weavers. Their owners provided them with minimal
housing, rations, and clothing. They lived without freedom or power and were subject to physi-
cal violence and psychological intimidation. Yet slaves retained a strong sense of identity. They
performed acts of daily resistance. They maintained resilient family networks and a sense of com-
munity. Before the war, many tried to escape to gain their freedom; later, many fought for it.

The War Begins

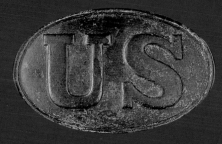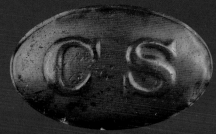

The nation's bloodiest and most divisive war began at Fort Sumter in Charleston, South Carolina, on April 12, 1861. After South Carolina seceded from the Union, the Confederacy demanded that the United States evacuate its fort in Charleston Harbor. Lincoln refused, provoking a Confederate attack. Surrounded and vulnerable, Union forces surrendered the fort after two days of bombardment. The outbreak of war forced wavering states to choose between the Confederacy and the Union, and four more—Arkansas, North Carolina, Tennessee, and Virginia—now seceded.

The Battle of Bull Run

The battle of Bull Run, the first major battle in the Civil War, ended in a Confederate victory. President Lincoln wanted to move quickly against the enemy, hoping a decisive victory would quell the rebellion. He ordered General Irvin McDowell to strike Confederate forces at Manassas Junction, as a step toward taking Richmond. Attacking early in the morning, Union forces first seemed to be winning, but the Confederates checked their advance. Confederate general Thomas Jackson earned the nickname "Stonewall" for his stout defensive stance. Late in the day, the Confederates counterattacked. Weary Union troops retreated, then panicked and fled helter-skelter back to Washington, D.C.

ABOVE (LEFT TO RIGHT)
Union belt buckle.
Confederate belt buckle.

BELOW
Fort Sumter under attack, 1861.

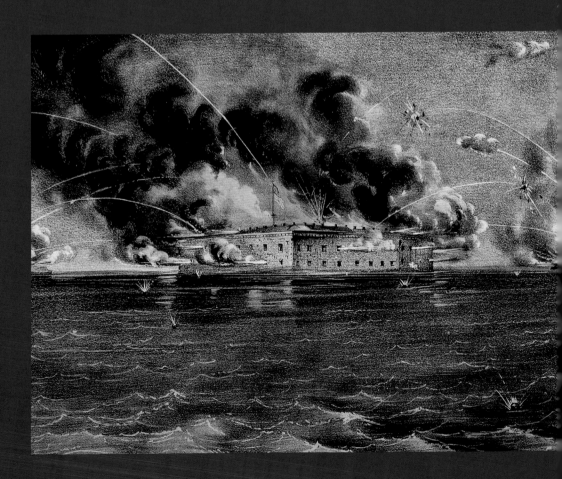

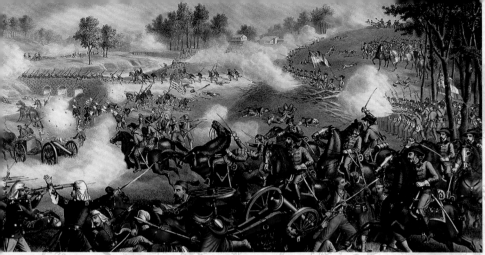
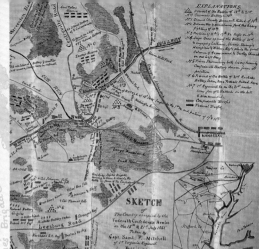

ABOVE (LEFT TO RIGHT)
Lithograph of the battle of Bull Run.

Map of the battle of Manassas, by Captain Samuel P. Mitchell of the First Virginia Regiment, 1862. Northerners and Southerners often referred to battles in the Civil War by different names. The North usually favored geographic features like rivers; the South favored towns. For example, known as the battle of Bull Run in the North, it was the battle of Manassas in the South.

BELOW (LEFT TO RIGHT)
Caps worn by Union and Confederate soldiers.

Confederate War Strategy

The goal of the Confederates was to win the war by not losing. The Confederates needed only to prolong their conflict long enough to convince the Union that victory would be too costly to bear. When opportunities arose, they would augment this strategy with selective offensive strikes. The Confederacy had fewer men, less capital, and less industrial capacity than the North, but its defensive strategy might prevail. And if it could convince France or England to recognize and support its government, chances of victory were even greater.

Union War Strategy

Unlike the Confederates, the Union had to fight and win an offensive war. Lincoln and his advisers developed a multipart strategy to defeat the South. First, they would negotiate with border states like Maryland to keep them in the Union. Second, they would blockade Southern ports, thus restricting trade with Europe. Third, they would capture strongholds along the Mississippi River, isolating the southwestern states from the eastern ones. Finally, they would advance into the Confederate heartland, especially toward its capital in Richmond, Virginia. Although details of this plan changed during the war, the basic outline remained the key to victory.

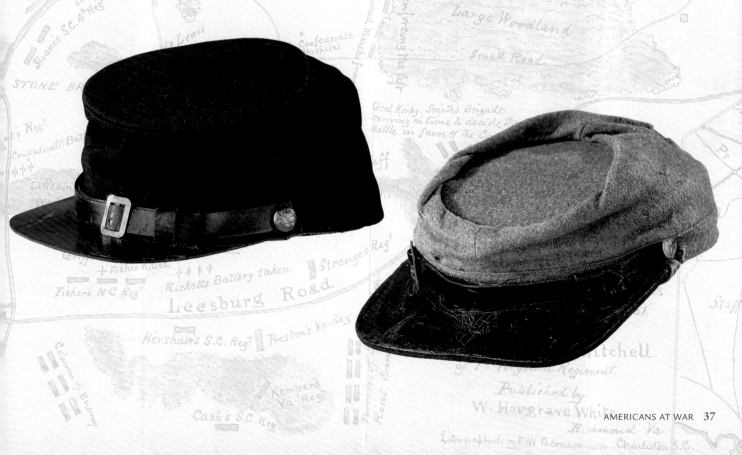

Soldiers in Blue and Gray

T he soldiers were young and inexperienced; most were in their teens or early twenties. In the North, they were farmers and factory workers, as well as newly arrived Irish immigrants. In the South, they were farmers, mechanics, and students. Most were volunteers; others were draftees unable to pay a substitute to go in their stead. Those who survived learned to be soldiers in the daily drills and discomforts of camp life, the exhaustion of miles-long marches, and the dry-mouth terror of battle.

Bloody Battles

Federal troops—and later Confederates—used advanced weapons: rifled muskets that fired spinning, cone-shaped minié balls; rapid-fire, breech-loading rifles; and rifled artillery. But both sides employed these weapons in traditional short-range fire between massed lines of soldiers, with deadly results. Many of the war's earliest casualties were left on the field for days before they died or were removed to hospitals. Surgeons amputated shattered limbs, probed wounds to extract bullets with their bare fingers, and stitched bowels together. Thousands of soldiers died from infections; but thousands survived—maimed, but alive.

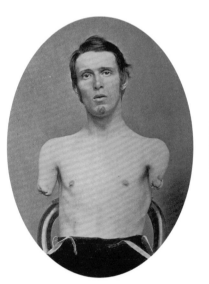
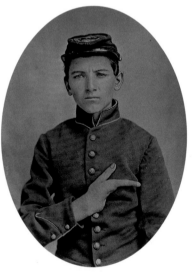
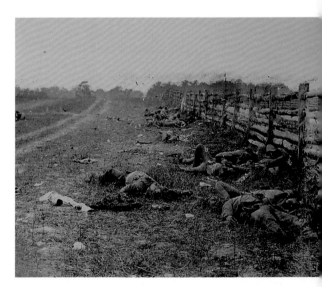

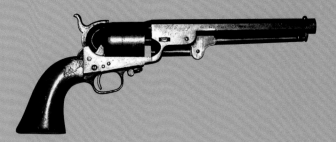

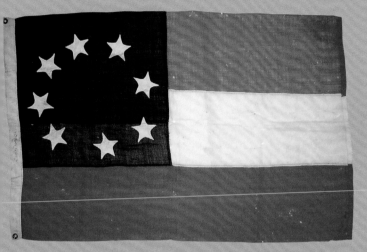

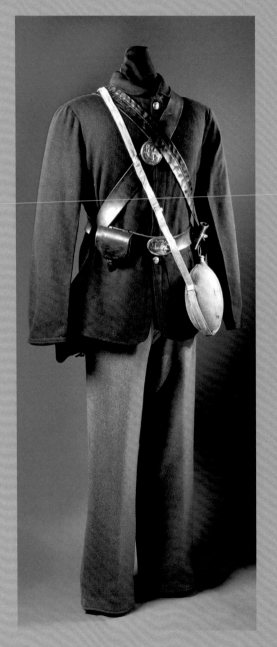

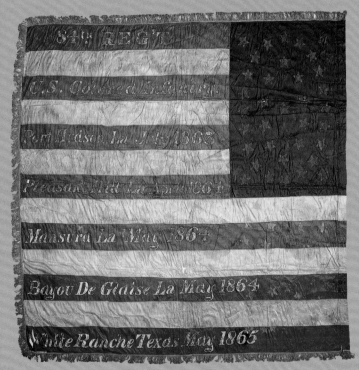

ABOVE (TOP TO BOTTOM)

.44-caliber Kerr revolver. The Confederacy bought nearly every one England made.

The Confederate States of America's first national flag, known as the Stars and Bars, was used until May 1863. In the midst of battle, it was sometimes confused with the Union flag.

Colors of the Eighty-Fourth Regiment of Infantry, United States Colored Troops (USCT), which fought in Louisiana and Texas. African Americans received three-quarters pay and mostly served under white officers.

German-made .44-caliber U.S. Model 1860 Colt army revolver.

Union infantry uniform and equipment.

Turning Points

BELOW (LEFT TO RIGHT)

Frock coat worn by General
George B. McClellan at Antietam.

Chromolithograph, *The Battle of
Antietam,* by Kurz and Allison, 1888.

Dead soldiers in the sunken road
at Antietam.

Antietam: America's Bloodiest Day

General Robert E. Lee crossed the Potomac River and carried the war into Maryland in September 1862. He had defeated the Union army on the Virginia peninsula in May and again at the second battle of Bull Run in August. Invading Union territory, he reasoned, might strengthen antiwar sentiment in the North and win the South recognition and aid from Europe. On September 17, Lee met General George B. McClellan in the bloodiest single day of fighting in the war—indeed, in American history. Union casualties at Antietam were 12,400, including 2,100 killed; Southern casualties were 10,320, including 1,550 killed. Although the outcome was a stalemate, Lee retreated to Virginia.

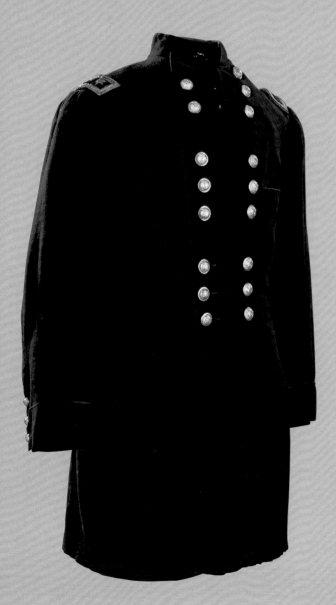

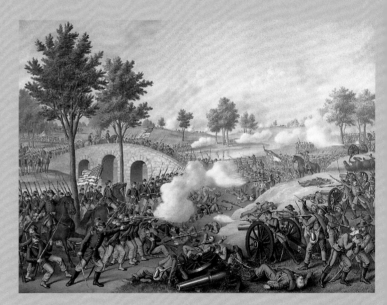

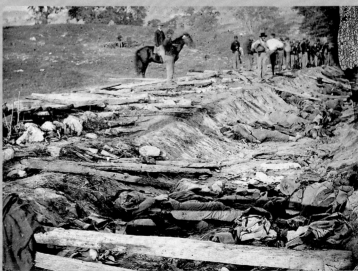

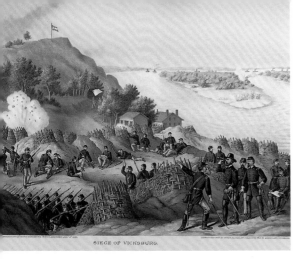

SIEGE OF VICKSBURG.

The Battle of Vicksburg

Union forces struggled to win control of Vicksburg, the Confederate stronghold atop bluffs over-looking the Mississippi River. During the first two years of the war, the Union army and navy secured Tennessee and won control of the upper and lower Mississippi. But they repeatedly failed to dislodge Confederate forces from their stronghold at Vicksburg. For months, General Ulysses S. Grant tried different approaches to take the city. Finally, in the summer of 1863, he resorted to a siege. For seven weeks, Union gunboats and land-based artillery bombarded the town and its defenses, armies clashed, and trapped residents huddled in caves and dirt bunkers. On July 4, 1863, Vicksburg surrendered.

The Battle of Gettysburg

After a major victory at Chancellorsville, Virginia, General Lee launched a second invasion of the North—and again failed. Marching seventy-five thousand men through Maryland into Pennsylvania, Lee hoped to reach Harrisburg. But General George Meade, now in command of the Army of the Potomac, met him at Gettysburg with eighty-eight thousand men on July 1, 1863. Meade's forces occupied the high ground. For three days, the two armies battled, with terrible losses. General George Pickett led the final Southern assault, against the center of the Union line. When it failed, Lee recognized defeat, retreated, and abandoned his hope of taking the war into Northern territory.

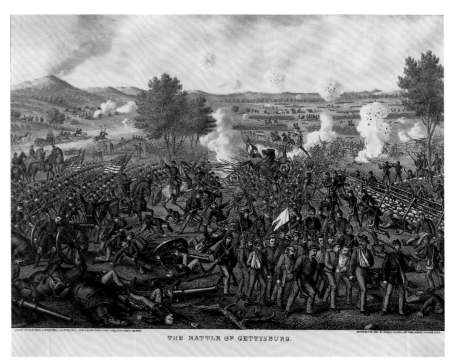

THE BATTLE OF GETTYSBURG.

Lincoln's Critical Decisions

Abraham Lincoln sat at the center of the war. Its outcome turned on his decisions about military issues and slavery. Throughout the war, Lincoln used military successes to help forward his political agenda.

Freeing the Slaves

Although Lincoln had always opposed slavery, he had not favored abolition when elected. But after the battle of Antietam, he decided that freeing the slaves in the rebellious South was critical to winning the war. The Emancipation Proclamation of January 1, 1863, made a negotiated settlement between North and South almost impossible. It solidified Lincoln's political support and ended the possibility that England would recognize the Confederacy. It encouraged Southern slaves to escape and join the Union army. And it was a major step toward a more just nation, where all would be free.

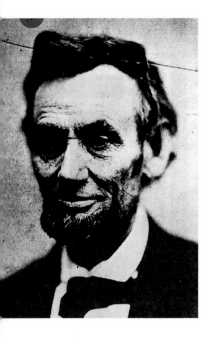

The last photograph taken of Abraham Lincoln, April 1865.

Commemorative lithograph of the Emancipation Proclamation, 1864.

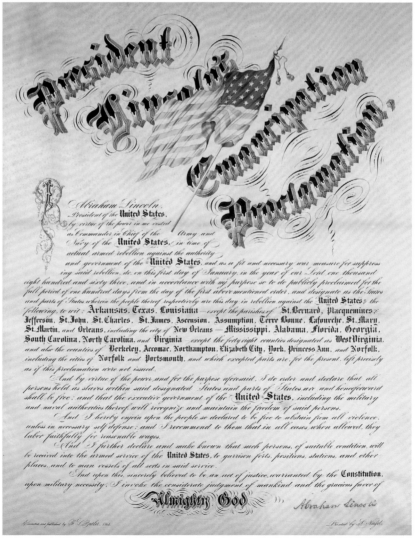

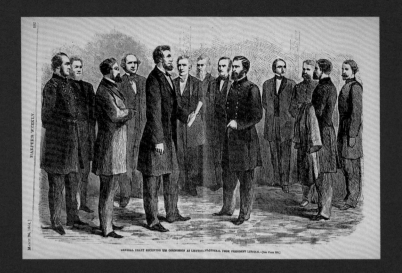

Lincoln Commissions Ulysses S. Grant as Lieutenant General, July 4, 1863.

Appointing Grant

In 1864, Lincoln named Ulysses S. Grant general in chief of all the armies and then supported him as he led the Union to victory. At the beginning of the war, the Union army had suffered from uneven senior leadership. Despite superior numbers, equipment, supplies, and rail transportation, however, Union generals continually lost important battles. Although Lincoln had little military experience himself, he exercised his authority as commander in chief and replaced his generals one after another. He finally found the determined military leader he sought in Grant.

Winning Reelection

To win the war, Lincoln had to maintain popular support and win reelection in November 1864. His Democratic opponent was George McClellan, the man Lincoln had named and then replaced as general of the Army of the Potomac. Although McClellan himself vacillated on negotiating peace, many of his supporters strongly favored it. In early 1864, Lincoln was convinced that a war-weary electorate would vote against him. But by election day, military successes by Generals Grant, Philip Sheridan, and William T. Sherman gave voters confidence that victory was near, and Lincoln handily won reelection.

Campaign posters for the 1864 election.

Commanders

Robert E. Lee and Ulysses S. Grant rose to become the most important commanders of the Confederate and Union armies. Lee's military expertise had been recognized before the war. He turned down President Lincoln's offer to command the Union army before he pledged his allegiance to the South. Hallmarks of Lee's leadership were his audacity, his skillful maneuvers, and his keen insight into his opponent's likely moves. Unlike Lee, Grant earned his reputation for military leadership during the Civil War. He became known for his persistence, ingenuity, and understanding of how to use Union superiority in manpower, weaponry, and logistics to his advantage.

BELOW (LEFT TO RIGHT)
"The Rebel General Robert Edmund [sic] Lee," *Harper's Weekly* cover image, July 2, 1864.

"Lieutenant-General Grant at His Head-Quarters," *Harper's Weekly* cover image, July 16, 1864.

Camp binoculars and chair used by Ulysses S. Grant.

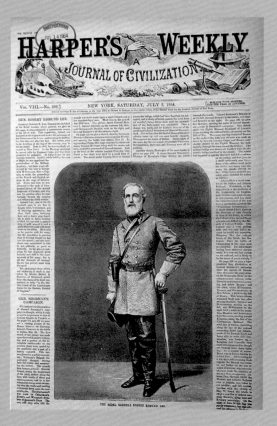

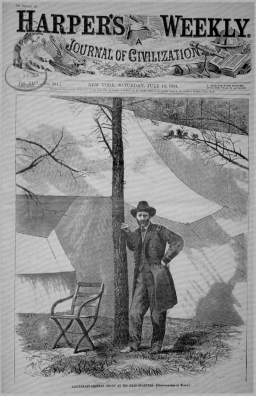

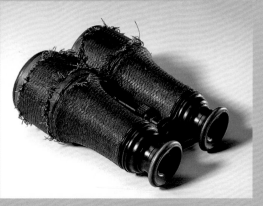

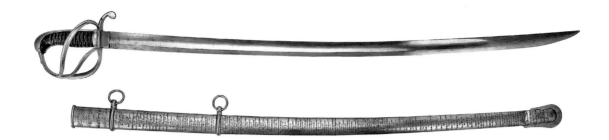

Cavalry saber and scabbard used by General Philip Sheridan.

Cavalry Leaders

Cavalry played many roles in the Civil War, including gathering intelligence, making lightning raids, and screening troop movements. Philip Sheridan was the most successful Union cavalry leader. Taking charge of the Army of the Potomac cavalry in 1864, he defeated Lee's cavalry in the battle of Yellow Tavern, Virginia, where Confederate leader J. E. B. Stuart was killed. Sheridan's cavalry later blocked Lee's retreat from Appomattox, forcing his surrender. In contrast to Sheridan, Confederate cavalryman John Mosby won his fame leading partisans—guerrillas—and using guerrilla tactics. With a small band of men, he wreaked havoc behind Union lines. A master of the lightning raid, his exploits earned him the nickname "Gray Ghost."

Navy Leaders

Naval operations along the coast and on the high seas were critical additions to land warfare. David Farragut stands out among the Union naval officers. Sixty years old when the war began, Farragut was still energetic and determined. In April 1862, he captured New Orleans. A year later he helped Grant take Vicksburg. Then in August 1864, he captured Mobile Bay and uttered his famous phrase, "Damn the torpedoes, full speed ahead!" A contrast to Farragut was the Confederacy's Raphael Semmes, who excelled in commerce raiding. He captured or sank some eighty ships valued at more than $6 million, most as commander of the CSS *Alabama*, a British-built sloop that attacked Union shipping from 1862 to 1864.

BELOW (LEFT TO RIGHT)
Cavalry jacket and slouch hat worn by Colonel John Mosby.

Service dress coat and cap worn by Admiral David Farragut.

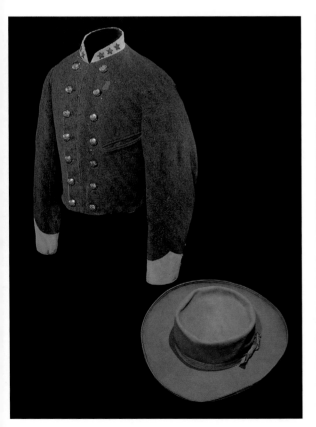

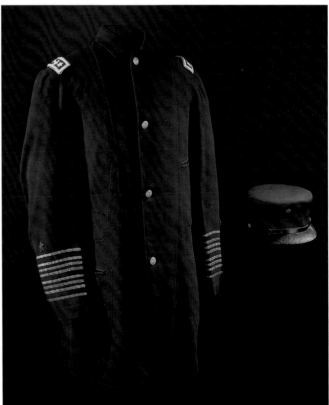

Total War

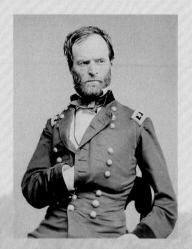

In March 1864, William T. Sherman assumed command of the Union army in the west. In May, he began a destructive march through the Southern heartland. Sherman had a different view of warfare than his contemporaries Grant and Lee. In his mind, wars were not between armies, but between people. Winning did not mean destroying the enemy's army, but crushing the people's will to fight. As Sherman marched south from Tennessee, he focused on making Southerners feel the horrible cost of war. By July he had fought his way to Atlanta and it fell on September 2. Sherman continued his campaign with a brutal march to the sea, spreading out his army and cutting swaths of destruction. Reaching Savannah in December, he presented its capture to Lincoln as a "Christmas gift."

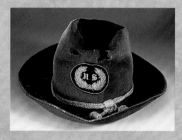

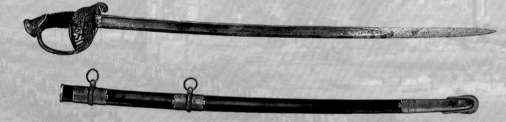

ABOVE (TOP TO BOTTOM)
General William T. Sherman.

Campaign hat worn by General William T. Sherman.

RIGHT (TOP TO BOTTOM)
Model 1850 staff and field officer's sword worn by General William T. Sherman during the battle of Shiloh, Tennessee, April 1862.

Ruins of Savannah houses.

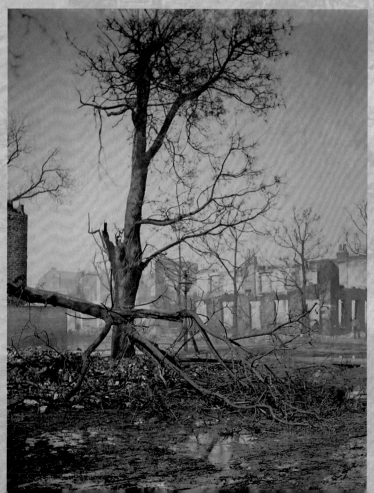

Surrender at Appomattox

In 1864, Ulysses S. Grant, now commander of all Union forces, pushed Robert E. Lee's Army of Northern Virginia from northeastern Virginia back to lines around Petersburg and Richmond. Here Lee dug in, forcing a ten-month siege. Finally, Grant's superior troop strength and resources gave him the upper hand. Lee abandoned the cities, hoping to continue fighting elsewhere. But as he moved west, he found his battered army surrounded and out-numbered and realized the end had come. On April 9, 1865, he surrendered to Grant. Grant offered generous terms, allowing the defeated army to return home with their small arms and giving them rations. Other Confederate armies soon gave up as well. Americans never forgot the ruthless conflict they had waged against each other, or its bitter legacy: 620,000 lost their lives; 400,000 had been scarred, maimed, or disabled.

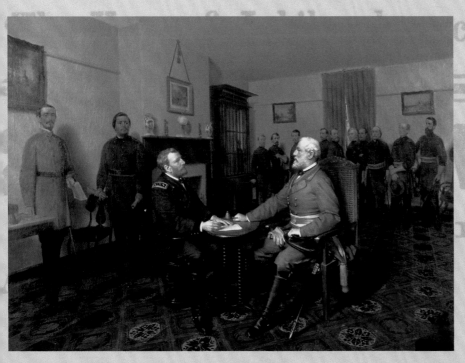

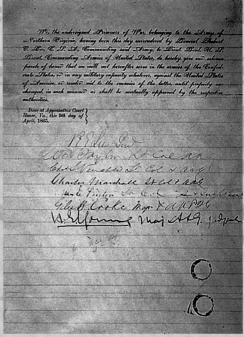

ABOVE (LEFT TO RIGHT)

The Surrender of the Army of Northern Virginia, by Louis M. D. Guillaume, 1867.

General Lee and his officers signed this parole document:

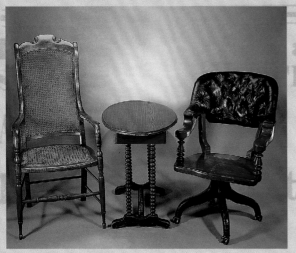

> *We, the undersigned prisoners of war belonging to the Army of Northern Virginia, having been this day surrendered by General Robert E. Lee, C.S. Army, commanding said army, to Lieut. Gen. U. S. Grant, commanding Armies of the United States, do hereby give our solemn parole of honor that we will not hereafter serve in the armies of the Confederate States, or in any military capacity whatever, against the United States of America, or render aid to the enemies of the latter, until properly exchanged, in such manner as shall be mutually approved by the respective authorities.*
>
> *Done at Appomattox Court House, Virginia, this 9th day of April, 1865*

LEFT

Chairs and table used at the surrender at Appomattox. Lee sat in the caned armchair, Grant in the upholstered chair. Grant signed the surrender document on the table. The furniture came to the Smithsonian early in the twentieth century.

Civil War Photography

The Civil War was the first war to be widely photographed, both on the battlefield and in portrait studios. Commercial photography had begun in the 1830s. By the 1840s, daguerreotype studios started appearing in U.S. cities and towns, bringing America's first boom in popular imagery. By the 1860s, new and faster processes were available. Especially popular were card photographs, or *cartes de visite*. These small, relatively inexpensive photographs were given to friends and family and collected in albums. Soldiers frequently had portraits made before they went to war, some realizing that these pictures might be their last.

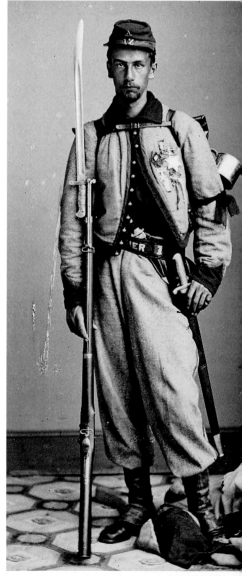

Examples of Civil War–era photography.

Legacies

The Civil War, America's bloodiest conflict, is also its most memorialized war. Shaping remembrance of the war would be the last act of the conflict. Although veterans groups formed immediately after the war, interest initially lagged. By the 1880s, however, old soldiers on both sides were looking back at their service with nostalgia and pride. Encampments, ceremonies, and veterans in parades became commonplace. Battlefields became parks. Thousands of memorials and cemeteries were dedicated. Beyond recognition and nostalgia, politicians in both the North and the South molded memories of the war in ways that would bolster their own agendas.

Constitutional Amendments

The Civil War led to three amendments to the U.S. Constitution, promising freedom and full rights of citizenship to African Americans. But racism delayed full implementation of the amendments and ultimately brought a new struggle for civil rights.

Thirteenth Amendment: Neither slavery nor involuntary servitude . . . shall exist within the United States.

Fourteenth Amendment: No State shall . . . deprive any person of life, liberty, or property, without due process of law; nor deny to any person within its jurisdiction the equal protection of the laws.

Fifteenth Amendment: The right of citizens of the United States to vote shall not be denied or abridged by the United States or by any State on account of race, color, or previous condition of servitude.

ABOVE
"Pickett's Charge of July 3, 1913," Confederate veterans reenact the battle of Gettysburg on its fiftieth anniversary.

BELOW (LEFT TO RIGHT)
The First Vote, by A. R. Wand, 1867.

And Not This Man?, by Thomas Nast, 1865, asked why Americans would be willing to trust pardoned Confederate soldiers to vote but not African Americans, many of whom had fought for the Union.

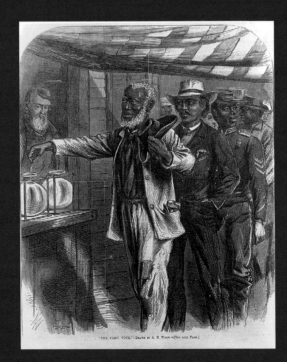
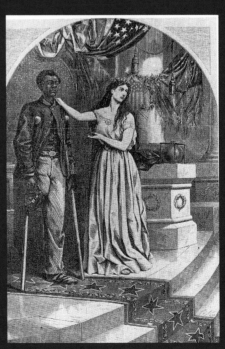

PART IV

The World Wars

During the first half of the twentieth century, the world endured two calamitous conflicts. The Great War—later known as World War I—erupted in 1914. Germany sided with Austria-Hungary (the Central Powers) against the Allied forces of Britain, France, and Russia. Armies on both sides dug in, facing each other in trenches that ran nearly five hundred miles across northern France—the notorious Western Front. Two years of horrific fighting resulted in huge losses, with no discernible progress by either side. After almost three years of troubled neutrality, the United States entered the war in 1917. Millions of American troops broke the stalemate, and the Central Powers agreed to an armistice in 1918. The United States emerged from the war a significant, but reluctant, world power.

The peace, however, was an uneasy one. A global economic depression in the 1930s—known in the United States as the Great Depression—resulted in political and social unrest worldwide. Instability eventually fostered the emergence of Imperial Japan, Nazi Germany, and Fascist Italy. Aggressively nationalistic and militaristic, the Axis powers ruthlessly pursued territory and power and threatened democracy in Europe, the Mediterranean, Asia, and the Pacific.

The first battles in what would become World War II took place when Imperial Japan invaded eastern China in 1937 and Nazi Germany invaded Poland in 1939. The United States joined Allied forces battling the Axis in 1941, resolved that the war could never end in a truce but would require the unconditional surrender and replacement of Axis governments.

World War I

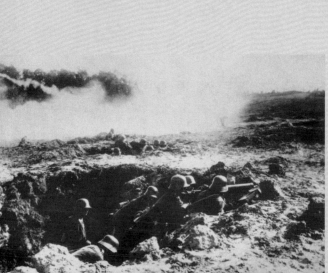

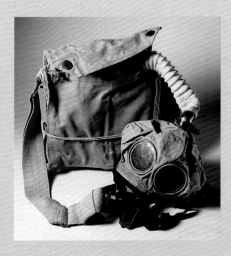

In 1914, World War I erupted in Europe. In a chain reaction, rival nations entangled in webs of reciprocal alliances took sides as Germany led the Central Powers in an assault against allied Britain, France, and Russia. Americans were reluctant to join this fight. President Woodrow Wilson tried to mediate, calling for "peace without victory," but the carnage continued.

When Germany began unrestricted submarine attacks on American ships and sought an alliance with Mexico to invade the United States, the president asked Congress to declare war. On April 6, 1917, the U.S. joined the allies. In part, the nation was responding to the growing threat against its economic and diplomatic interests. But it also wanted, in the words of Wilson, to "make the world safe for democracy."

The first contingent of the American Expeditionary Force (AEF) commanded by General John J. Pershing reached France in June, but it took time to assemble, train, and equip a fighting force. Two million Americans volunteered for the army, and nearly three million were drafted. More than 350,000 African Americans served, in segregated units. For the first time, women were in the ranks, nearly 13,000 in the navy as yeoman (F, for female) and in the marines. More than 20,000 women served in the Army and Navy Nurse Corps.

By spring 1918, the AEF was ready, first blunting a German offensive at Belleau Wood and then driving back the German lines. The war finally ended in an armistice on November 11. Americans rejoiced, but the Senate rejected the Treaty of Versailles peace pact and Wilson's attempt to include the United States in the new League of Nations. The brief foray into internationalism had not only exposed the nation to the horrors of war but also the flu pandemic that killed millions worldwide.

Many Americans longed for a return to the isolationism and social stratification of the prewar years. But others wanted change. Women won the vote, partly for their wartime service. African Americans wanted to keep opportunities gained during the war, but they had little success.

LEFT TO RIGHT
Shovels were as important to soldiers as weapons.

Germans awaiting an Allied assault in the Somme, 1918.

Army gas mask and carrying bag, critical during a war in which chemical weapons, such as mustard gas, were used on the battlefield.

World War I "doughboy" helmet.

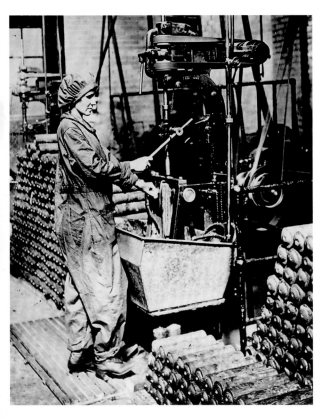

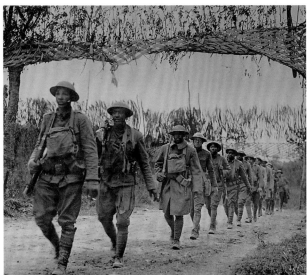

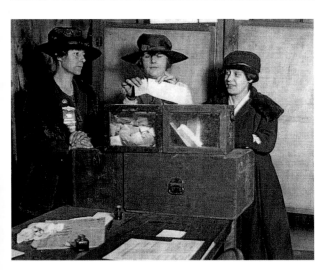

TAKE UP THE SWORD OF JUSTICE

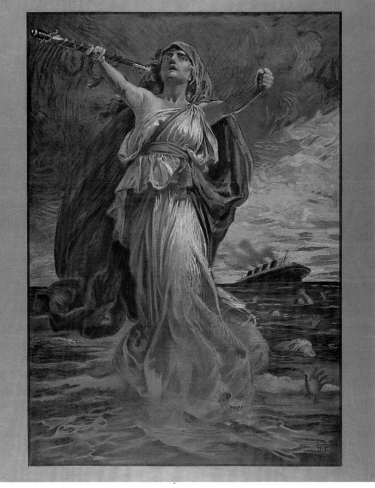

LEFT (TOP TO BOTTOM)

Under unprecedented government direction, American industry mobilized to produce weapons, equipment, munitions, and supplies. Nearly one million women joined the workforce. Hundreds of thousands of African Americans from the South migrated north to work in factories.

African American soldiers fought in segregated units.

Recognition of women's war service helped them win the right to vote in 1920.

ABOVE

Anger after a German U-boat sank the British ocean liner *Lusitania,* depicted in this British poster, convinced many Americans that they should join the war effort.

Warfare, Weapons, and Wounded

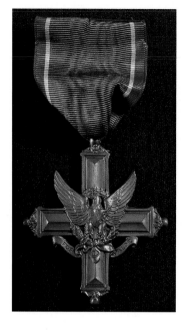

During World War I, linear tactics from the nineteenth century met deadly weapons of the twentieth century with disastrous results. Onrushing lines of infantrymen were slaughtered by rapid-fire machine guns. The development of the internal combustion engine resulted in the first use of tanks on the battlefield. Horse-drawn ammunition caissons commingled with gasoline-powered ambulances. Airplanes flew overhead marking enemy positions, dropping bombs on the trenches, and tangling with enemy airplanes in what became known as "dogfights." Mechanized warfare had been born.

Casualties of War

Machine guns, poison gas, and a variety of other weapons killed tens of thousands on both sides, but far more troops died under the rain of artillery shells. The dead—often only parts of bodies—were carried back from the front lines. Frequently, an American ambulance driver noted, "there wasn't anything left to bring." Nevertheless, advances in hygiene and the rigorous use of antiseptics saved many soldiers who might have died in an earlier war during surgery. Some survivors were left with disfiguring head and facial injuries. This spurred innovations in reconstructive surgery and facial prosthetics.

ABOVE
Distinguished Service Cross awarded to General John J. Pershing.

BELOW
Stubby, mascot of the 102nd Infantry, 26th Division, accompanied his unit in the trenches. He received numerous awards for his service.

Heroes

Two million men in the American Expeditionary Force went to France. Some 1,261 combat veterans—and their commander, General John J. Pershing—were awarded the Distinguished Service Cross, the nation's second-highest award for extraordinary heroism. Sixty-nine American civilians also received the award.

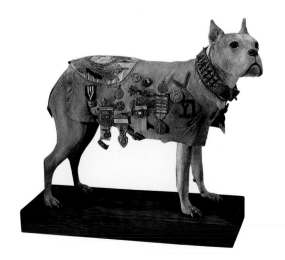

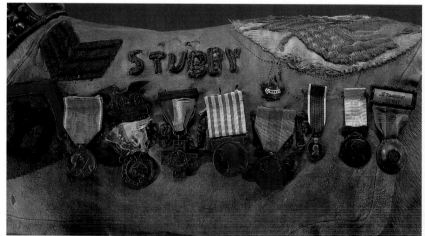

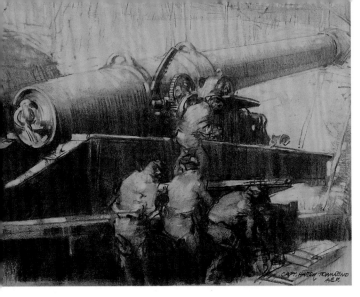

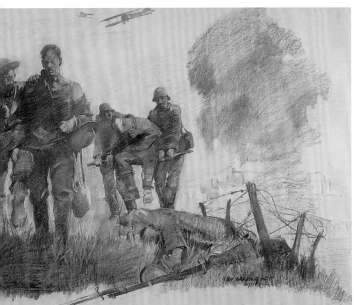

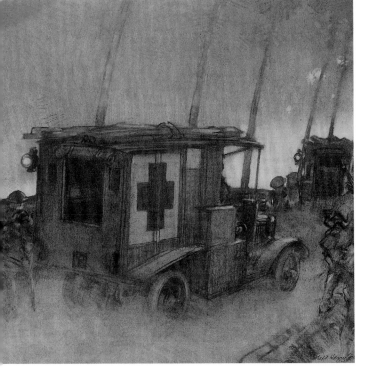

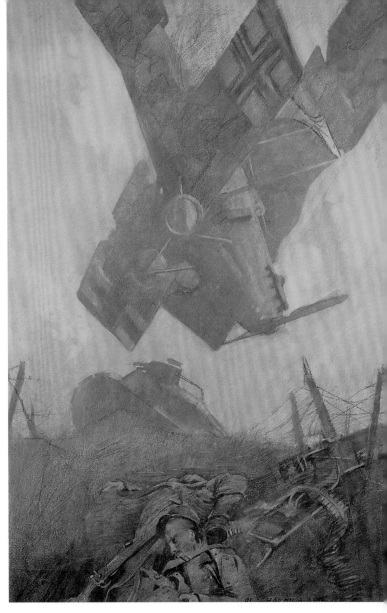

Battlefield sketches by Harry Townsend, George Harding, and Harvey Dunn. The sketches depict a variety of modern war technologies: tanks, airplanes, machine guns, gas, and motorized ambulances.

.30-caliber Model 1915 Vickers machine gun.

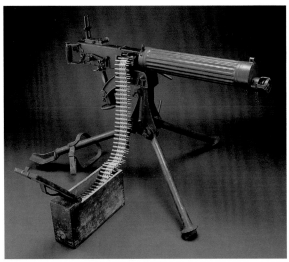

Prelude to World War II

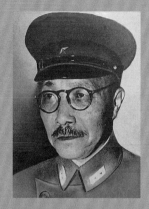

A mericans went to war to protect the United States and the world from aggressive nationalism and militarism.

Imperial Japan

In an ominous prelude to World War II, Japanese forces swept into eastern China in 1937 and laid waste to Shanghai and Nanking. Japan's leadership proclaimed this the first step in creating a "New Order" that would rid Asia and the Pacific of Western colonial and imperial influence. Japan had annexed Korea in 1910 and taken control of Manchuria in 1931; in 1940, General Hideki Tojo directed the occupation of resource-rich French Indo-China, now Vietnam. By December 1941, Japan was poised to expand across the Pacific Rim, threatening British Malaya, the Dutch East Indies, the American Philippines, and even Australia.

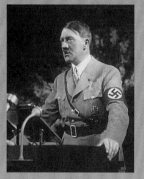

Nazi Germany

Adolf Hitler and his Nazi Party swept to power in 1934. Immediately, he began a vengeful and compulsive quest to remake Germany—and the world. He rebuilt Germany's war machine, mobilizing industry and expanding the military. He seized territory—the Rhineland in 1936, Austria and portions of Czechoslovakia in 1938, and Poland in 1939—sparking World War II. In 1940, he launched attacks on Great Britain and took France. He invaded the Soviet Union in 1941 and even set his sights on the United States. Simultaneously, Hitler began the systematic mass murder of Jews and other groups he considered "undesirable."

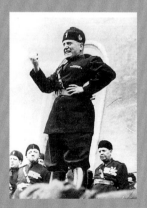

Fascist Italy

Benito Mussolini became dictator of Italy in 1925. He did little to realize his dreams of restoring the glory days of the Roman Empire. Beyond a blustering propaganda campaign, his military gains were limited to seizing easy targets: Ethiopia in 1936 and Albania in 1939. In 1940, as the German blitzkrieg spread across Europe, Mussolini allied himself with Hitler and opened a self-described "parallel war" in the Mediterranean. He dispatched ill-prepared Italian forces to North Africa and Greece, hoping that an eventual German victory would win Italy the right to claim these territories for itself.

TOP TO BOTTOM
Hideki Tojo
Adolf Hitler
Benito Mussolini

LEFT TO RIGHT
Italian flag
Nazi flag
Japanese flag

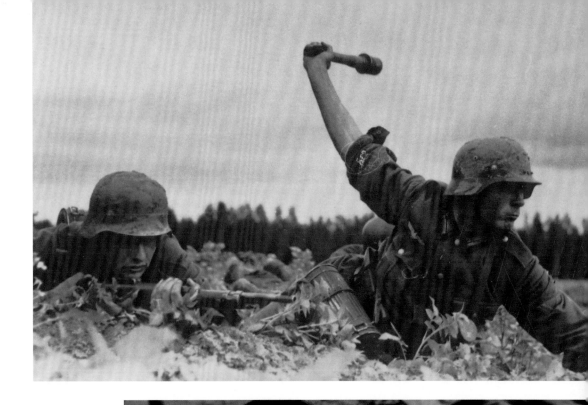

CLOCKWISE FROM TOP LEFT

German Field Marshal Werner von Blomberg's baton. Made minister of war and commander in chief of the German army in 1935, Blomberg required his soldiers to pledge an oath of personal loyalty to Hitler. In April 1936, Blomberg became Hitler's first field marshal.

A German infantryman hurling a grenade.

A Nanking woman following a brutal Japanese raid, 1937.

A Japanese samurai sword, a tangible symbol of military authority.

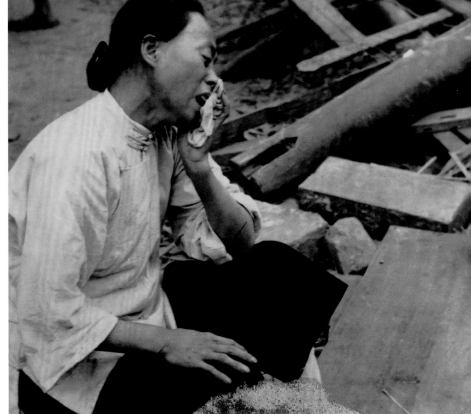

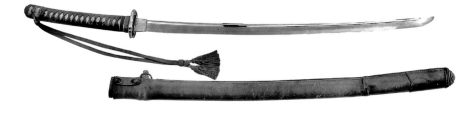

Pearl Harbor

At 7:55 A.M. on December 7, 1941, the quiet of a Sunday morning on Hawaii's island of Oahu was shattered by the drone of low-flying planes, followed by thundering explosions and strafing gunfire, and then by wailing sirens and antiaircraft fire. Nearly two hundred Japanese bombers, torpedo and dive-bombers, as well as fighters swarmed over U.S. naval bases and airfields, bombing and strafing ships and aircraft. Fifteen minutes later a second wave attacked. By 10:00 A.M., eighteen ships were listing or sunk in the oil-slicked and burning waters of Pearl Harbor; 292 aircraft were destroyed; nearly 2,500 Americans were dead; more than 1,000 were wounded. The next day, President Franklin Delano Roosevelt asked Congress to declare war on Japan.

Purple Heart medal awarded to a seaman killed in action aboard the USS *Arizona* on December 7, 1941.

President Roosevelt addresses a joint session of Congress on December 8, 1941.

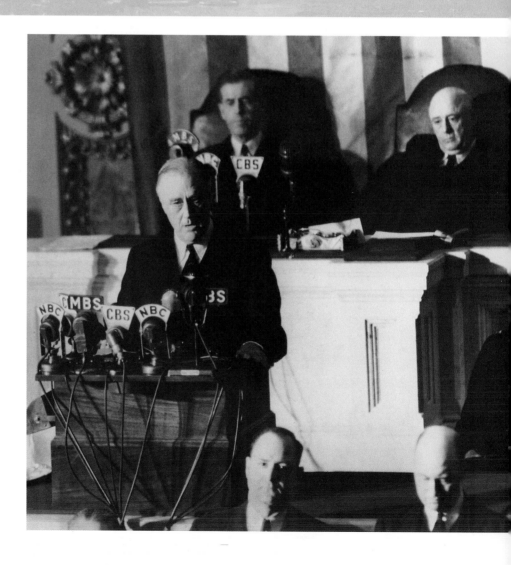

ZRU NPL ✕✕✕ ZRG2 L Z F5L 071830 C8Q TART O O

FROM:- CINCPAC ✕✕✕✕✕✕
ACTION ;- ALL SHIPS/HAWAIIAN AREA
PRESENT

AIRRAID ON PEARL HARBOR X THIS IS NO DRILL

ABOVE
Radiogram announcing the attack.

"We Are Now in This War"

On December 8, Congress rallied to President Roosevelt's call, voting to declare war on Japan; Roosevelt signed the declaration the same day. On December 11, Nazi Germany and Fascist Italy declared war on the United States. For Americans, the global war that had been raging for nearly two years was just beginning.

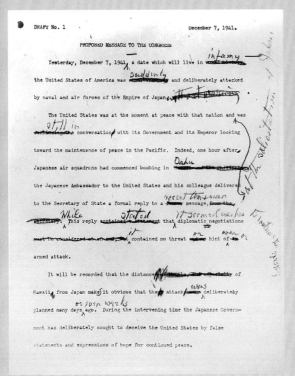

ABOVE
Typewritten draft of President Roosevelt's address to Congress, with his hand-written revisions.

RIGHT
Poster issued by the U.S. Office of War Information, 1942.

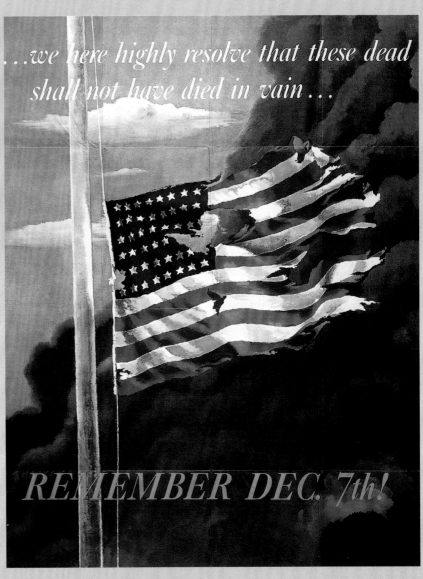

...we here highly resolve that these dead shall not have died in vain...

REMEMBER DEC. 7th!

Mobilizing for War

War Production

The sheer mass—and seemingly endless supply—of American-produced war materiel would overwhelm the Axis.

- 5,600 merchant ships
- 8,800 warships
- 79,000 landing craft
- 88,000 tanks
- 224,000 pieces of artillery
- 324,000 aircraft
- 2,382,000 trucks
- 2,600,000 machine guns
- 15,000,000 guns
- 20,800,000 helmets
- 41,000,000,000 rounds of ammunition

This data is from *The Oxford Companion to World War II* (1995) and *The World War II Databook* (1993).

"We are all in it—all the way," President Franklin Roosevelt told Americans during a radio broadcast two days after the United States entered the war. "Every single man, woman and child is a partner in the most tremendous undertaking of our American history." Sixteen million donned uniforms. The millions more who stayed home comprised a vast civilian army, mobilized by the government to finance the war effort, conserve natural resources, and produce a continuous flow of war materiel.

The Arsenal of Democracy

By 1941, American defense industries were already churning out planes and ships, trucks and tanks, guns and shells, and supplies and equipment. Tons of war materials were being shipped to Britain and other nations battling Axis advances. As America joined the fight and battlefronts multiplied around the globe, demands on war production skyrocketed. Civilian industries retooled: making tanks instead of cars, for example. And as men went off to war, nine million women took their places in factories.

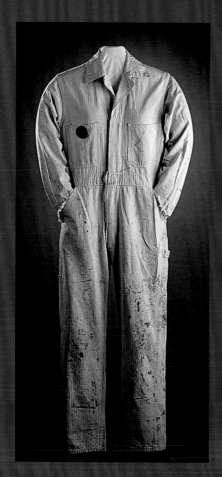
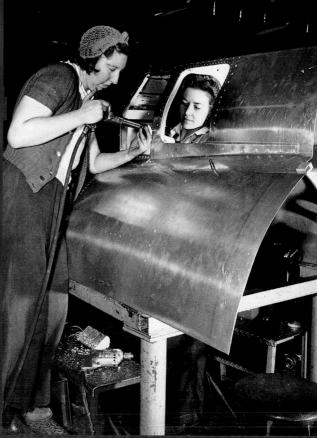

LEFT TO RIGHT

Woman's war work coveralls.

Women workers riveting a section of a B-17 bomber.

The War at Home

A junior bombardier, 1942.

Wartime posters.

As natural resources—even agricultural output—were diverted to support the troops, Americans endured shortages and rationing. War production devoured cotton, silk, nylon, wool, leather, and rubber: little was left for civilian clothes or shoes. The U.S. government rationed natural fibers, forbid drastic style changes that might tempt buyers, and restricted the length of skirts and the fullness of pants and jackets; even cuffs were banned. In 1942, the government began rationing gasoline to conserve limited supplies of fuel, but, more important, to save wear on a vehicle's tires and help conserve rubber. Foods were rationed, too: first sugar, then fresh meat, butter, cheese, vegetables, juices, and canned goods.

There's a War On

The war permeated nearly all aspects of everyday life in America. Newspapers, radio broadcasts, and movie newsreels tracked the war's progress. Movie theaters were filled with patriotism-building, morale-boosting movies that pitted heroic Americans against caricatures of villainous Nazis and fanatical Japanese—and depicted a home front united for victory. Even for children, the reality of a nation at war could not be avoided. Many of their favorite characters from the funny pages and comic books were transformed into soldiers, sailors, and airmen. Toys and games encouraged them to make-believe that they were on the front lines, albeit with wooden guns, because metal was needed for war production.

You're in the Army Now

The United States summoned millions of American men for "training and service" in U.S. land, naval, and air forces. Many joined up; most were drafted. They all found themselves at mobilization camps and training centers across the country: they received a haircut, immunizations, a stack of uniforms and gear, a bunk, a footlocker—and a rude awakening. Most had just weeks to learn soldiering, the technicalities of weapons systems, or the complexities of support services. Then they faced the realities of war.

A Star in the Window

Reviving a practice begun during World War I, millions of families—one in five—displayed blue star flags in the front windows of their homes. Each star proclaimed a son or daughter in military service. If a loved one was killed, a gold star covered or took the place of the blue one.

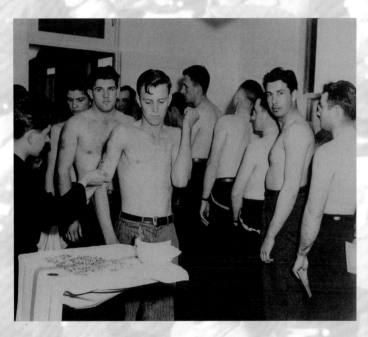

TOP
The service flag.

LEFT TO RIGHT
Recruits at a U.S. Naval training station in San Diego, California.

An African American drill sergeant at work.

So Others Might Fight

RIGHT

WAAC jacket. Thousands of soldiers were assigned to secretarial and clerical support. After 1942, most were women; they served in the Women's Auxiliary Army Corp (WAAC), later the Women's Army Corp (WAC), the Navy WAVES and Coast Guard SPARS, and the Marine Corps' Women's Reserve.

So Others Might Fight

Not every soldier in America's vast war machine carried a weapon or was shipped overseas. Most of those in uniform—including all 650,000 women in the armed forces—were support troops. Many were responsible for training, deploying, and sustaining fighting forces. Many more procured, transported, and maintained the materiel and technologies needed to wage war.

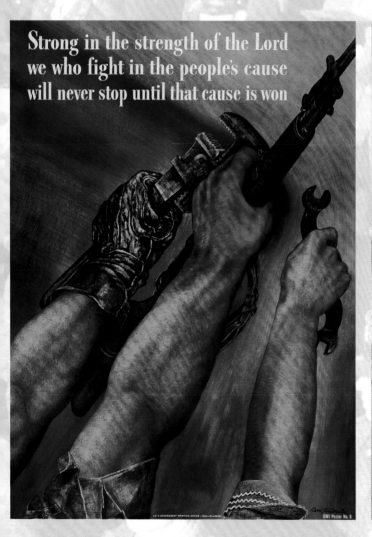

Strong in the strength of the Lord
we who fight in the people's cause
will never stop until that cause is won

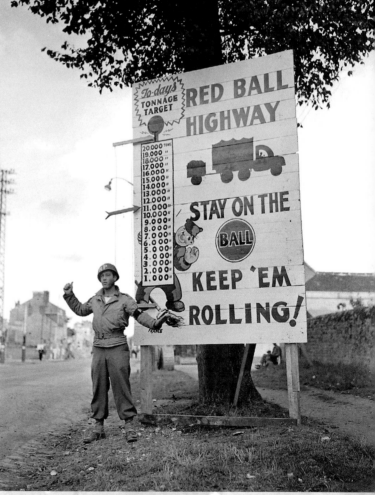

Army recruiting poster. The most vital weapon employed during the war was often a wrench wielded by the soldiers—men and women—serving as mechanics that maintained and repaired vehicles and weapons systems.

Trucks were often the last links in the logistical chain. In an operation dubbed the "Red Ball Express," nearly six thousand drivers—mostly African Americans—supported the Allied advance toward Paris in summer 1944.

The Battle of the Atlantic

Tons of American-produced supplies and war materiel, as well as hundreds of thousands of U.S. troops, had only one way to get to Europe: in ships crossing the North Atlantic. German submarines, or U-boats, posed a constant threat to Allied vessels, even ships in U.S. coastal waters. By war's end, more than twenty-five hundred Allied ships had been sunk. Despite this, Allied counterattacks ultimately destroyed most of the U-boat fleet.

The Convoy System

Because lone ships at sea were most vulnerable to attacks by prowling German U-boats, the Allies began to dispatch supply and troop ships in groups: at first, several ships were accompanied by a single destroyer; soon dozens of vessels, sometimes more than a hundred, were sailing together with multiple warships. Airplanes acted as spotters, first flying in patrols above coastal waters and later launched from escort ships. Convoys, as well as ever-improving detection technologies and antisub weaponry, ensured that thousands of tankers, merchant ships, and troop transports made safe—albeit nerve-racking—crossings.

LEFT TO RIGHT
Uniform worn by U.S. Navy–enlisted men.

Convoy bound for North Africa.

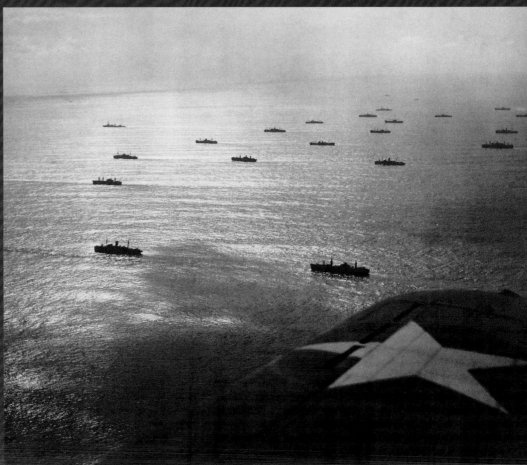

The Mediterranean Theater

In 1941, President Franklin Roosevelt and British Prime Minister Winston Churchill agreed to destroy Nazi Germany first, then Imperial Japan. With Germany battling Russia along a front that stretched from Leningrad to Stalingrad, U.S. war planners wanted to open a second front in German-occupied France. But Roosevelt deferred to Churchill: the Allies would first attack in the Mediterranean, the "soft underbelly" of Nazi-occupied Europe.

North African Campaign

In 1942, U.S. forces attacked the Axis, joining the British who had been battling Italian and German advances in North Africa for two years. Supported by hundreds of warships, support vessels, bombers, and fighters, Allied troops put ashore along Africa's northern coast, then pushed east to join the fight against Axis strongholds in Tunisia. Allied air, naval, and ground forces were initially outmatched and often stopped but gradually isolated the Axis army. Months of brutal fighting ended in the war's first Allied victory and taught green U.S. troops and commanders hard lessons about combat.

Sicily and Italy

In July 1943, half a million Allied soldiers, sailors, and airmen were deployed in a massive amphibious assault against German and Italian forces on Sicily, a rocky island just south of Italy's "boot." British and American commanders—often at odds and fiercely competitive—struggled to coordinate operations: they quickly won the island, but most of the enemy escaped. Lightly resisted landings in Italy in September belied the bloody struggle that lay ahead. It took nine months for Allied forces to fight their way to Rome; many would never reach Germany.

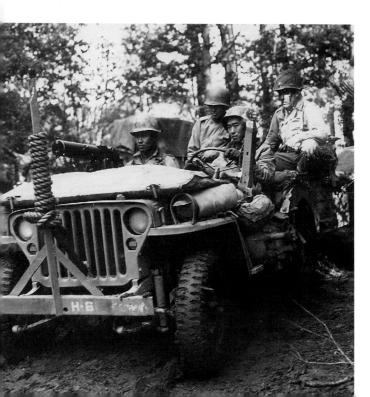

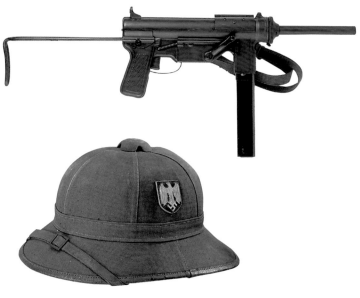

Storming Fortress Europe

In spring 1943, Winston Churchill relented and agreed to support American plans for a direct assault on Nazi-occupied Europe. That fall, Premier Joseph Stalin—mired in a brutal fight along Germany's eastern front—enthusiastically endorsed the plan. By spring 1944, a year of Allied bombing had weakened Germany's war machine, destroying oil refineries, factories, aircraft plants, and rail networks.

D-Day

On June 6, 1944, a massive Allied force under the overall command of General Dwight D. Eisenhower crossed the English Channel bound for northwestern France. As twelve thousand bombers and fighter planes poured inland, nearly seven thousand Allied navy and merchant vessels pushed toward the beaches of Normandy. Wave after wave of American, British, and Canadian troops hit the beaches. Hundreds were killed in withering fire from concrete pillboxes atop high bluffs. Allied forces tenaciously fought their way forward, securing a foothold in France.

Fighting for France

In the days following D-Day, two million Allied troops poured into France. In bitter fighting, they battled their way across France. By mid-September, the Allies had liberated Paris, were in control of Belgium, and stood ready to strike Germany.

The Russian Front

Germany invaded the Soviet Union in 1941 and rapidly advanced inland, establishing a front that stretched from Leningrad to Moscow to Stalingrad. The Germans quickly found themselves mired in a brutal fight they could not win—and would not give up. Losses on both sides were astronomical.

BELOW (LEFT TO RIGHT)
Boeing B-17s attack Nazi-occupied Europe.

General Dwight Eisenhower speaks to paratroopers bound for France.

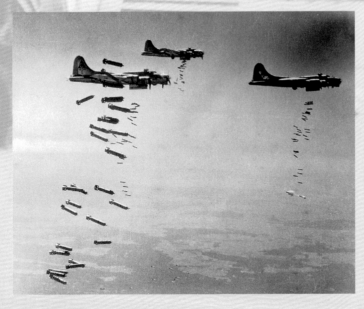

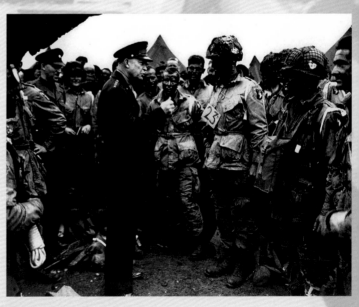

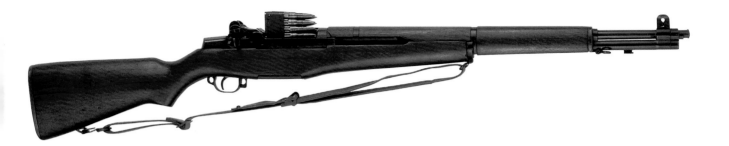

ABOVE
.30-caliber U.S. M-1 "Garand" rifle.

The Battle of the Bulge

Massed Allied troops were on the border of Germany along a two-hundred-mile front when the Nazis mounted a surprise offensive on December 16, 1944. The Allied line bulged but did not break. A month of bitter fighting in winter cold and deep snow cost the Allies one hundred thousand casualties; almost twenty thousand Americans were killed. The battle further depleted Germany's disappearing resources and fighting forces as between eighty thousand and one hundred thousand German troops were killed, wounded, or captured during the fighting.

On to Berlin!

BELOW (LEFT TO RIGHT)
M4 Sherman tanks at the battle of the Bulge.

A U.S. M-1 helmet.

A German army helmet.

By 1944, the Russians were on the offensive. They drove German forces out of Soviet territory, Eastern Europe, and the Balkans; then surged into Germany from the east. In early spring 1945, Allied infantry and armored divisions, in concert with a massive bombing campaign, pushed toward Berlin from the west. Along the way, they freed Allied POWs from prison camps and discovered unthinkable horrors at Nazi death camps. In the first week of May—following Adolf Hitler's suicide on April 30—the Nazi regime collapsed. Berlin fell to the Soviets, and Axis armies in Italy gave up.

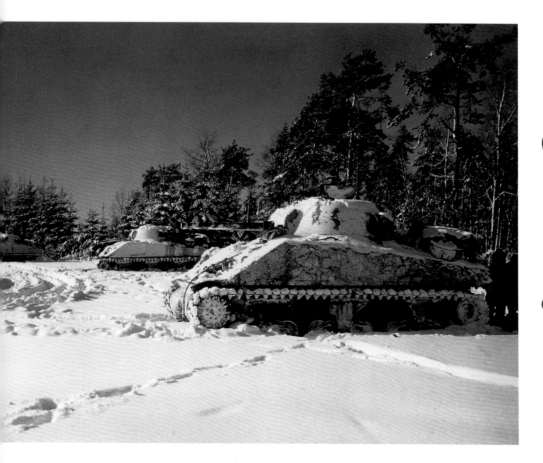

The War in the Pacific

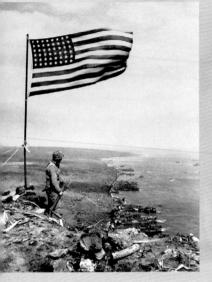

While fires still roiled out of control at Pearl Harbor, Japanese forces attacked targets across the Pacific. Over the next three weeks, they swept across eastern Asia, nearly to Australia, and invaded the Philippines. Because the Allies had agreed to give highest priority to defeating Germany and Italy, resources for combating Japan were limited. Still, the Allies began fighting back.

The Tokyo Raid

On April 18, 1942, Army Air Forces Lieutenant Colonel Jimmy Doolittle led sixteen B-25 bombers on a daring raid against Tokyo. Launched from aircraft carriers nearly eight hundred miles out to sea, most of his planes hit targets near the capital. Although the raid caused only modest damage, it embarrassed the Japanese army, who was responsible for protecting Tokyo, and greatly boosted U.S. morale. The attack also resulted in a shift of military control to the Imperial Navy, which now pushed forward its plans to expand its sphere of influence.

Miracle at Midway

In June 1942, the Japanese attacked the Midway Islands as a step toward taking Hawaii. U.S. forces, however, having broken Japanese codes, lay in wait for their enemy. When the two fleets clashed, the Japanese initially seemed to be winning, easily destroying two waves of U.S. attack planes. Then a few U.S. dive-bombers caught the Japanese carriers with planes refueling and sank three of them. Another was damaged and sank later. Although the U.S. also lost a carrier, it was replaced by U.S. industry; the Japanese never fully recovered.

ABOVE
Iwo Jima, February 1945.

BELOW (LEFT TO RIGHT)
Lieutenant Colonel Doolittle lifts off from the aircraft carrier USS *Hornet* on April 18, 1942.

U.S. aircraft carriers in the Pacific.

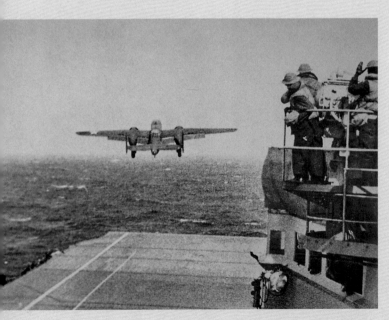

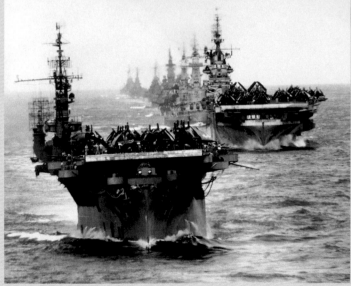

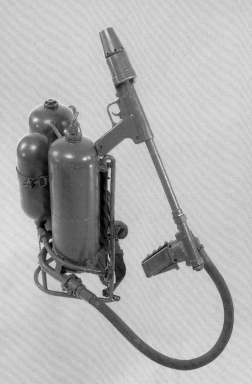

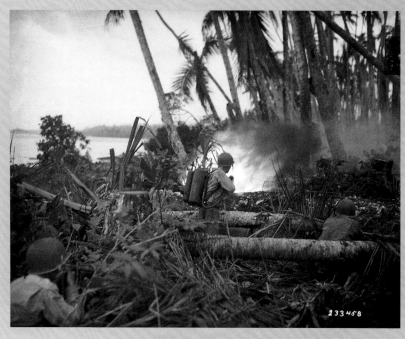

ABOVE (LEFT TO RIGHT)
A U.S. M2A1 flamethrower.

A flamethrower, Solomon Islands, 1943.

BELOW (LEFT TO RIGHT)
American dead in Papua, New Guinea, 1943.

A navy life jacket.

Across the Pacific

In 1943, the Army and Navy jointly began a two-pronged attack through the central Pacific and across New Guinea to the Philippines. Fast carrier task forces and Army bombers attacked the targeted islands while slower amphibious forces made bloody assaults on island strongholds. Once captured, the islands became airfields and supply hubs for the next attack.

In the south, Allied forces continued west around Rabaul, bound for the Philippines, supported by the Army Air Forces and, at times, the central Pacific Fleet. Gradually, the Americans pushed the Japanese back and opened the way to assault their homeland.

In October 1944, General Douglas MacArthur returned to the Philippines and began pushing back Japanese forces. In March 1945, Iwo Jima fell, followed by Okinawa in June.

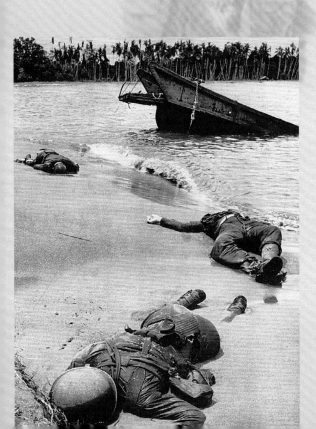

The Final Blows

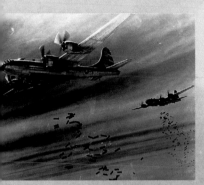

Boeing B-29 bombers firebomb Japan.

In March 1945, the U.S. Army Air Forces intensified their strategic bombing campaign over Japan. Having failed to hit targets accurately from high altitude, U.S. bombers began low-flying nighttime attacks on cities using incendiary bombs. The resulting firestorms devastated industrial, military, and civilian property without discrimination. By mid-June, more than sixty cities and industrial centers were burned to the ground. Aerial mines were dropped in harbors, while the U.S. Navy launched carrier air attacks against coastal targets. Still, the Japanese refused to surrender. They even began sending pilots on kamikaze suicide missions, using their airplanes as guided weapons against U.S. aircraft and ships, sinking 34 Allied vessels, damaging 288 others, and killing more sailors in one month than had perished in the previous two years of fighting. An invasion of Japan seemed inevitable.

The A-Bomb

In July 1945, President Harry Truman made his controversial decision to use atomic weapons against the Japanese. More than a million Allied troops were moving to invade Japan when the B-29 *Enola Gay* dropped a single bomb that destroyed Hiroshima on August 6, 1945. On August 9, a second atomic bomb leveled Nagasaki, and Japan surrendered.

"We have used [the bomb] against those who attacked us without warning at Pearl Harbor, against those who have starved and beaten and executed American prisoners of war. . . . We have used it in order to shorten the agony of war, in order to save the lives of thousands and thousands of young Americans."
—*President Truman*

"The enemy has begun to employ a new and most cruel bomb, the power of which to do damage is indeed incalculable, taking the toll of many innocent lives. . . . This is the reason why we have ordered the acceptance of the provisions of the Joint declaration of the Powers."
—*Emperor Hirohito*

President Harry S. Truman.

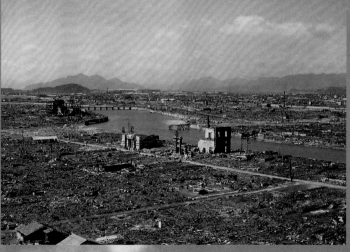

Destruction at Hiroshima.

Victory and Peace

World War II came to an end in 1945 with the crushing defeat and unconditional surrender of Nazi Germany and Imperial Japan. But the toll the war had taken in human suffering and lives lost was staggering—nearly sixty million people died worldwide.

Victory!

The Allies celebrated the collapse of Nazi Germany and their victory in Europe on V-E Day, May 8, 1945. Across Britain, Europe, and the United States jubilant crowds took to the streets: their elation—their relief—was tempered by the realization that war still raged in the Pacific. But the celebrating was unabated on August 15, 1945, when Imperial Japan admitted defeat. "This is the day we have been waiting for since Pearl Harbor," said President Truman. "This is the day when Fascism finally dies. . . ." Surrender documents would be signed on September 2 in a ceremony aboard the USS *Missouri* in Tokyo Bay.

Peace!

Peace was won, but an uncertain future lay ahead. Although the American economy was booming and the nation's spirits were high, eight years of war had left cities worldwide in ruin, economies in shambles, and civilian populations displaced and ripe for unrest. The United States championed the establishment of the United Nations and dared to hope that the new UN would keep world peace and safeguard U.S. economic and political interests worldwide. Even as tensions with the Soviet Union grew, American forces were rapidly demobilized, and millions of GIs returned home determined to make the most of their hard-won peace and the nation's prosperity.

ABOVE
A World War II victory medal.

BELOW (LEFT TO RIGHT)
The Allies celebrate victory, 1945.

United Nations poster.

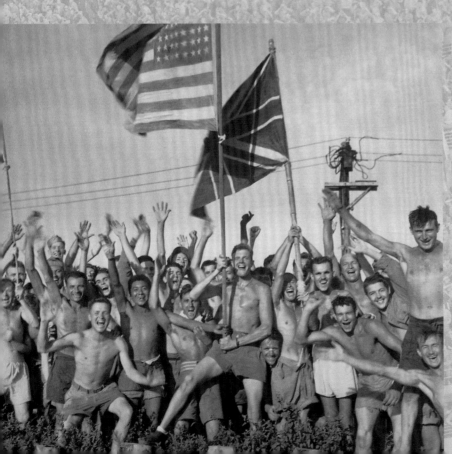

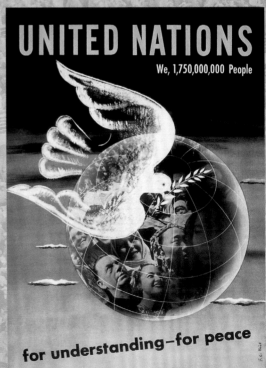

PART V

The Cold War

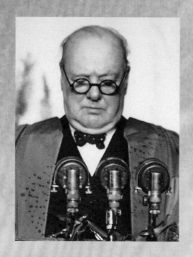

"From Stettin in the Baltic to Trieste in the Adriatic an iron curtain has descended across the Continent. Behind that line lie all the capitals of the ancient states of Central and Eastern Europe . . . all these famous cities and the populations around them lie in what I must call the Soviet sphere."

—*Winston Churchill at Westminster College, in Fulton, Missouri, on March 5, 1946*

Winston Churchill delivers his "Iron Curtain" speech at Westminster College.

The global competition between the United States and the Soviet Union known as the Cold War started after World War II. President Harry S. Truman defined it as freedom and capitalism versus totalitarianism and Communism. He set the precedent for a policy of containment, bolstering any ally who stood in the way of Soviet expansion.

In 1949, the Cold War became a nuclear arms race when the Soviets detonated an atomic bomb. U.S. military and intelligence services knew that the Soviets were developing an atomic bomb but assumed it was years in the future. The American public was stunned. In an understatement, a secret report prepared by the Pentagon noted: "The United States has lost its capability of making an effective atomic attack upon the war-making potential of the USSR without danger of retaliation in kind."

In January 1950, five months after the Soviet Union successfully exploded an atomic bomb, Truman authorized the development of a thermonuclear "superbomb"—a device a thousand times more powerful than the atomic bomb dropped on Hiroshima. A secret study prepared for the president warned that if the Soviets were to develop an H-bomb before the Americans, "the risks of greatly increased Soviet pressure against all the free world, or an attack against the U.S., will be greatly increased." The United States exploded its first hydrogen bomb in 1952; the Soviets followed in 1953.

Bolstering Allies

In the opening struggles for control of postwar Europe, the United States used economic aid and humanitarian relief efforts to support the democracies of Western Europe and stymie the territorial advances of the Soviet Union.

The Marshall Plan

Following World War II, much of Europe lay in ruin, its economies in shambles. Through the European Recovery Act, better known as the Marshall Plan, the United States poured more than $12 billion in food, raw material, capital equipment, and economic investment into Western Europe. War-weary Europeans welcomed the temporary aid program that ran from 1948 to 1951. But wary Soviet leaders saw it as a ploy for the United States to succor its own postwar economy—and to establish a permanent presence within sight of Soviet-controlled Eastern Europe.

OPPOSITE
U.S. coal being unloaded in the Netherlands during the Marshall Plan.

ABOVE (LEFT TO RIGHT)
Douglas C-47 "Skytrains" line up and load up during the Berlin airlift. Most cargo was carried by the U.S. Air Force, which had become an independent service in September 1947. The Royal Air Force lifted about a quarter of the supplies, and France contributed as well. U.S. Navy C-54s joined the operation three months into the airlift and delivered about 7 percent of the tonnage carried by U.S. aircraft.

Small parachutes like this one were used to drop candy and "goodies" to the children of Berlin during airlift operations.

The Berlin Airlift

Postwar Germany was divided into four sections controlled by France, Great Britain, the Soviet Union, and the United States. Berlin, located deep within the Soviet occupation zone, was further divided into four sectors, with West Berlin occupied by the Allies and East Berlin by the Soviets. In June 1948, the Soviets attempted to take control of the entire city by cutting off surface traffic to and from West Berlin. Truman responded with a continuous airlift that served as a lifeline for besieged West Berlin. Allied Douglas C-47s and C-54s and additional cargo planes carried food, fuel, and other desperately needed supplies into the city twenty-four hours a day. The Soviets finally backed down, lifting the blockade in May 1949, shortly after the United States and its European allies established the North Atlantic Treaty Organization (NATO) for their mutual defense. The airlift ended in September.

Hot War: Korea

On June 25, 1950, North Korean leader Kim Il Sung launched the invasion of South Korea in an attempt to reunify the nation under Communism. The Soviets supported his decision with economic and military aid. As Communist forces poured across the thirty-eighth parallel, South Korean troops scattered in disarray, and civilians streamed south. U.S. reinforcements initially failed to stem the tide, and the North Koreans pushed the coalition allies into the southeast corner of the peninsula, near Pusan. Truman interpreted the invasion as an attempt by Moscow to expand its domain and test Western resolve. He committed American troops and rallied support in the United Nations, establishing a coalition of sixteen nations to mount a counterattack.

Changing Battlefronts

UN forces under the command of General Douglas MacArthur turned the tide and battled their way north, pushing North Korean troops to the Yalu River. With Allied troops threatening their border, Communist China joined the fight and launched a ferocious counteroffensive that drove UN troops south again. Soon, the battlefront stagnated. Three years of brutal fighting left Americans divided over the war. An uneasy truce split the Korean peninsula into a Communist north and democratic south.

Troops in Korea served in integrated units; Truman had ordered the desegregation of U.S. armed forces in 1947.

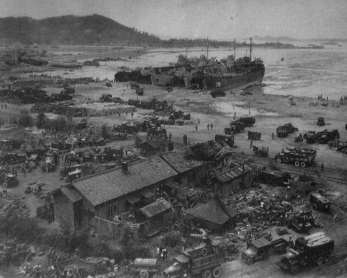

Landing at Inchon in September 1950. While UN forces prepared to push north from Pusan, U.S. troops made a daring amphibious landing at Inchon. Supported by naval gunfire and air bombardment, troops poured onto the beach and then threatened the enemy from behind. The North Koreans retreated north rather than risk being trapped in a closing vise.

BELOW (LEFT TO RIGHT)
The North American F-86 Sabre, America's first swept-wing jet fighter, was deployed in Korea. The nimble jets provided air superiority against enemy aircraft and support for ground troops.

A soldier from the Nineteenth Infantry Regiment, January 1951, attempts to keep warm.

Weather Extremes

Summers in Korea were intolerably hot and humid; temperatures often topped 110 degrees Fahrenheit, and humidity hovered at 90 percent or higher. Winters were bitterly cold with fierce winds, stinging sleet, and drifting snow; temperatures often dropped below –30 degrees Fahrenheit. Soldiers bundled up, often using their ponchos for shelter, but the cold was penetrating. "You get cold to the bone," recalled an American soldier. "It's hard to thaw out."

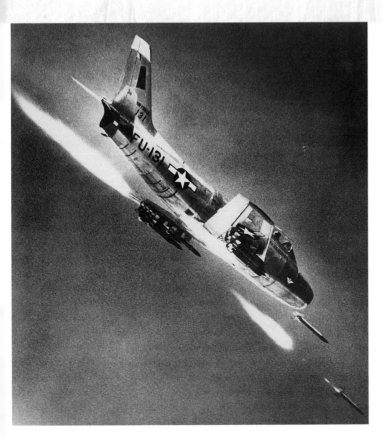

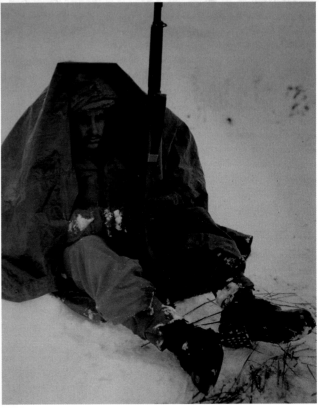

The Cuban Missile Crisis

A U-2 spy plane.

BELOW (LEFT TO RIGHT)
B-52 bomber crews race to their aircraft.

USS *Essex* heading to participate in the blockade of Cuba.

In the late 1950s, the threat of nuclear war heightened Cold War tensions. The United States and the Soviet Union targeted each other's capitals and other major cities for attack. Both nations raced to stockpile long-range ballistic missiles with payloads that could not be intercepted. In October 1962, the standoff between the United States and the Soviet Union over nuclear missiles in Cuba was a turning point in the Cold War.

Nuclear Brinksmanship

When President John F. Kennedy learned that the Soviet Union was deploying nuclear missiles in Cuba, he demanded they be withdrawn and indicated his willingness to risk nuclear war if they were not. U.S. ships blockaded Cuba. American bombers loaded with nuclear weapons flew in holding patterns just beyond Soviet airspace, ready to attack. The crisis abated only when the Soviets agreed to remove the missiles, and the United States quietly removed similar medium-range missiles from Turkey. In the aftermath of the face-off, the superpowers continued to develop nuclear weapons but also sought ways to avoid a nuclear exchange.

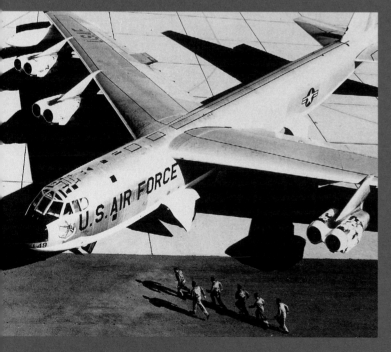

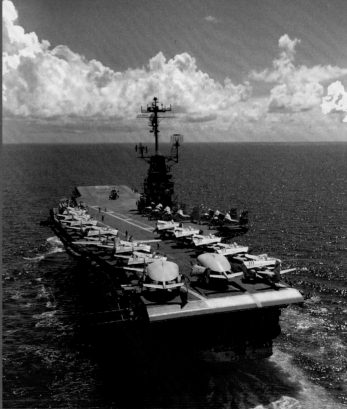

Hot War: Vietnam

ABOVE
A U.S. Army green beret.

BELOW
Images of the Vietnam era.

A Special Forces helmet, Army of the Republic of South Vietnam.

During World War II, the United States had supported Vietnamese nationalist Ho Chi Minh in his struggle against the Japanese. But after the war, when he sought assistance from Communist powers to win independence from France, the United States opposed him as an agent of Communist expansion. When a 1954 agreement partitioned Vietnam into Communists in the north and anti-Communists in the south, President Dwight D. Eisenhower sent hundreds of military advisers and $1 billion to bolster South Vietnam. By 1963, President John F. Kennedy had increased the number of advisers to more than sixteen thousand and tripled U.S. financial support.

A Divisive War

When President Lyndon B. Johnson sent thousands of air and ground forces to Vietnam in 1964, after the passage of the Tonkin Gulf Resolution, most Americans supported him. As casualties mounted and the draft expanded, antiwar sentiment grew. In 1968, the Tet Offensive—a widespread Communist assault—deepened disagreements over the war's conduct and meaning. In 1970, President Richard Nixon began to withdraw American troops but expanded the war into Cambodia and Laos, resulting in widespread protests at home. U.S. forces left Vietnam in 1973 and South Vietnam fell to the Communists in 1975.

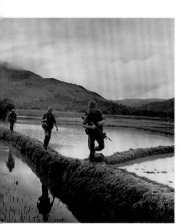

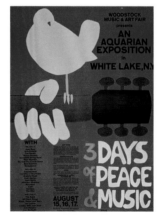
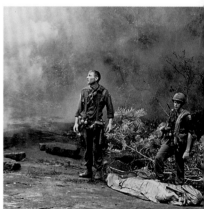

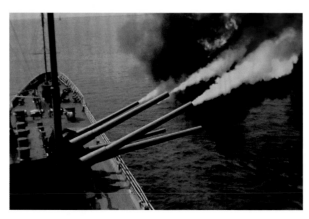
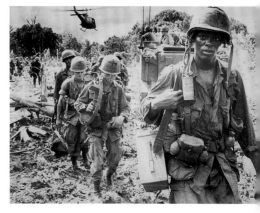

Fighting the Vietnam War

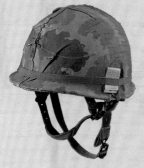

ABOVE

A U.S. M-1 helmet with camouflage cover on which a soldier tracked the months remaining in his tour of duty.

BELOW

A B-52 bombs enemy targets over Vietnam.

An American infantryman, 1971.

The U.S. M-16A1 automatic rifle, the standard-issue individual weapon for the U.S. Army and, after 1968, the U.S. Marines.

By 1968, 536,000 U.S. troops were deployed in Vietnam, a country not twice the size of Florida. North Vietnam was the target of repeated U.S. bombings, but South Vietnam was the setting for bombings, defoliation, and most of the fighting. The war also spilled over into Laos and Cambodia.

The Surface War

Infantrymen—"grunts" on the ground—and those who manned riverine and coastal patrol boats bore the brunt of the fighting. They endured extreme heat, humidity, and frequent rains; they faced enemy fire and booby traps. They fought with tenacity and were successful in conventional combat operations in the field. As the war dragged on, however, direct political control over military operations stifled initiative and had detrimental effects on the morale of soldiers abroad and civilians at home. By 1967, home-front protests had become widespread. Many Americans became increasingly disillusioned with the purpose of the war and their odds of winning. Standards fell while military bearing and personal appearance in many units degraded. Much of the popular music the troops favored reflected a loss of hope and a need to "get out of this place."

The Air War

Pilots and aircrews flew tens of thousands of missions during the war, ranging from tactical resupply to close air support to strategic bombing. B-52 bombers attacked broad areas, while smaller carrier- and land-based fighters and bombers attacked enemy supply lines and

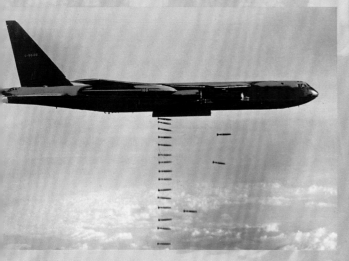

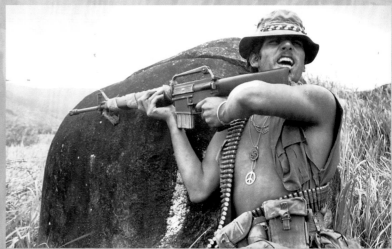

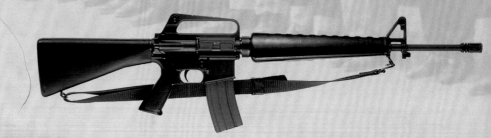

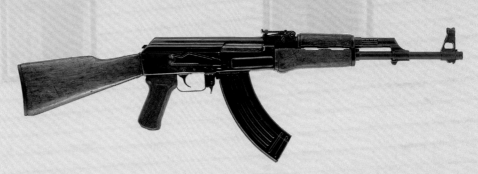

ABOVE
A Chinese-made AK-47 automatic rifle used by Vietcong and North Vietnamese troops.

BELOW
Civilian porters pushing over-loaded bicycles transported tons of supplies along the Ho Chi Minh Trail, a series of rough roadways and footpaths that led from North Vietnam through the highland jungles of Laos and Cambodia to South Vietnam.

strongholds, often bombing targets selected by Johnson during Sunday morning breakfast meetings. Vietcong and Vietnamese surface-to-air missiles and antiaircraft artillery shot down many planes. Although the United States retained air superiority, the limited application of airpower during the war could not provide decisive results in Southeast Asia.

The Enemy

The North Vietnamese and Vietcong followed the ancient principles of guerrilla war: when the enemy attacks, retreat; when the enemy digs in, harass; when the enemy is exhausted, attack. They employed modern weaponry, including Soviet- and Chinese-supplied aircraft, antiaircraft artillery, and surface-to-air missiles. They used improvised weapons as well, such as recycled U.S. explosives, homemade rifles, trip-wired booby traps with crossbows, and concealed nail-studded boards, even excrement-coated bamboo punji sticks that could pierce a boot.

Workhorse of the War: The Huey

During the war in Vietnam, helicopters flew patrols, attacked enemy positions, delivered supplies, carried troops into combat, and retrieved the wounded and the dead. Helicopters, such as the Bell UH-1—nicknamed "the Huey"—were crucial to army air mobility, a tactic devised in Vietnam for fighting a war without frontlines. Ground troops were lifted into widely dispersed locations to engage the enemy, then extracted and redeployed. Nearly four thousand Hueys served during the war.

Inserting Troops

Huey transports carried thousands of troops into battle, seven to twelve infantrymen at a time. The choppers could fly low and slow, dodge enemy fire, hover just above ground level at the outskirts of hamlets or fields of elephant grass, or drop into newly cut jungle clearings barely larger than the sweep of their rotors. The transports were nicknamed "slicks" because they were unarmed except for an M-60 machine gun in the doorway. Often they were accompanied by Huey gunships armed with external machine guns and rocket and grenade launchers that covered landing troops.

Removing Casualties

Rapid combat-casualty evacuations flown by daring "Dustoff" crews—pilots, medics, and crew chiefs—extracted nearly four hundred thousand wounded from battle zones during the course of the war. Helicopters made it possible for the wounded to be on a surgeon's table in a hospital within an hour. Crews commonly put themselves at great risk, flying in and out of intense fighting. They repeatedly witnessed the horrible realities of war. During a mission, the air would be permeated with what one soldier described as "the sickeningly sweet redolence of fresh blood."

An "LZ," or landing zone, in Vietnam.

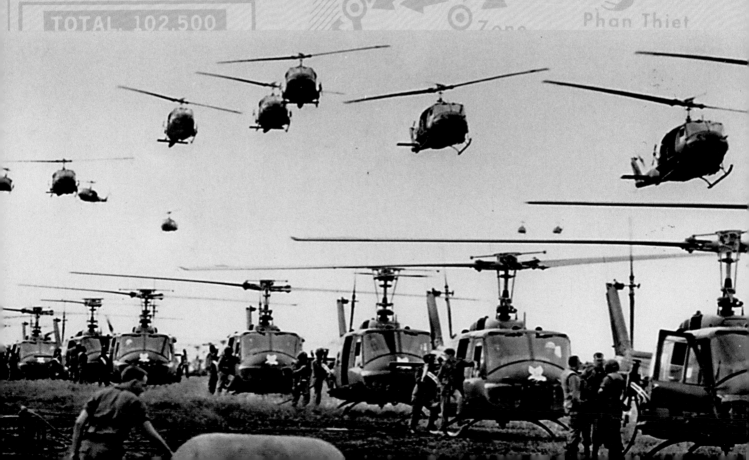

Number 091 made its last flight on March 19, 2004. The Huey flew over the Vietnam Veterans Memorial in Washington, D.C., circled Arlington National Cemetery, and then landed on the National Mall in front of the Smithsonian's National Museum of American History. The Huey is the largest single artifact in *The Price of Freedom* exhibition.

091

This Huey, with tail number 65-10091, was deployed to Vietnam in 1966 and served with the 173rd Assault Helicopter Company, known as the Robinhoods. After being shot down in combat, it returned to the United States, where it was repaired and then continued to fly until 1995 when it was decommissioned and acquired by the Texas Air Command Museum. In 2002, the 091 was featured in a documentary film and a tour of reconciliation and remembrance that brought Vietnam veterans and their stories to people across the nation.

American POWs in Vietnam

From 1961 to 1973, the North Vietnamese and Vietcong held hundreds of Americans captive in North and South Vietnam, Cambodia, China, and Laos. In North Vietnam alone, more than a dozen prisons were scattered in and around the capital city of Hanoi. American POWs gave those prisons nicknames: Alcatraz, Briarpatch, Dirty Bird, the Hanoi Hilton, and the Zoo. Conditions were appalling. Prisoners were variously isolated, starved, beaten, tortured, and paraded in anti-American propaganda. "It's easy to die but hard to live," a prison guard told one new arrival, "and we'll show you just how hard it is to live."

Resolute Resistance

American POWs in Vietnam struggled to survive horrid conditions, physical pain, and psychological deprivation, often for years on end. They exercised as best they could. Some played mind games to keep themselves sane, making mental lists or building imaginary houses, one nail at a time. They drew strength from one another, secretly communicating via notes scratched with sooty matches on toilet paper, subtle hand gestures, or code tapped out on their cell walls.

POWs in the Public Eye

Americans were painfully aware of the nearly eight hundred men who were prisoners of war in Vietnam. The North Vietnamese paraded them in a sophisticated propaganda campaign to erode public support for the war. POW families launched awareness campaigns, and the media gave the POW situation extensive coverage. At war's end, about six hundred returned home. Some Americans believe that thousands more "missing in action" were left behind.

An American POW in a staged photograph showing clean, spacious accommodations, 1969. The reality was far more brutal and cramped, however.

Artifacts from former POWs.

TOP LEFT
Uniforms like this, nicknamed "pinks," were issued to American POWs.

The Vietnam Veterans Memorial

The memorial wall that bears the names of men and women killed or missing in Vietnam from 1956 to 1975 has become a place where Americans honor those who died and reflect on their feelings about the war. Veterans seek out the names of their buddies; families and friends look for the names of loved ones. They mourn, remember, and come to terms. Many leave flowers or letters or treasured keepsakes. Others, not searching for a name, realize that the lives of those named on the wall are connected by history to their own. When the memorial wall was dedicated in 1982, the 57,939 names were carved into its polished black panels. Several hundred names have been added in the years since.

A collection of articles left at the wall.

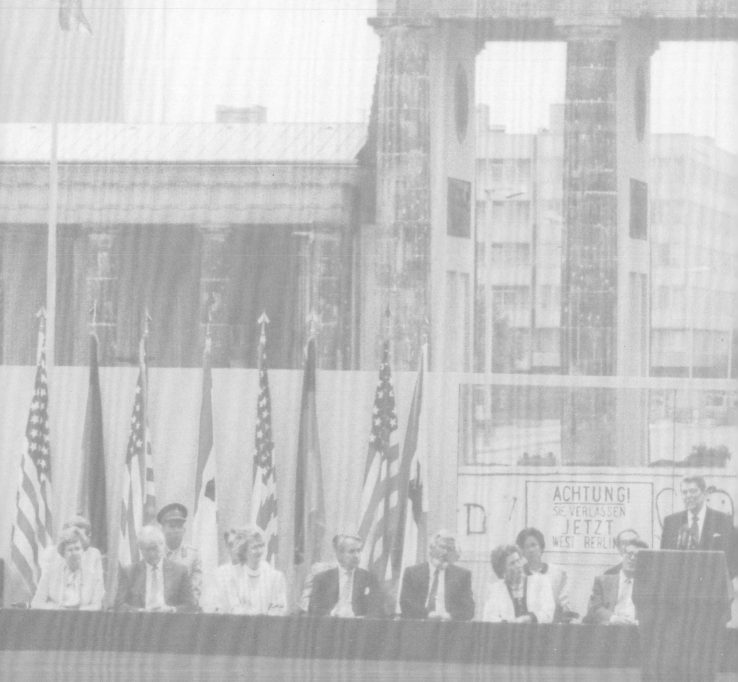

New American Roles

In 1987, President Ronald Reagan stood at the Berlin wall and declared that the free world had bested Soviet Communism. "Freedom is the victor," he said, "if you seek peace, if you seek prosperity for the Soviet Union and Eastern Europe, if you seek liberalization: Come here to this gate! Mr. Gorbachev, open this gate! Mr. Gorbachev, tear down this wall!" Two years later, on November 9, 1989, the wall fell. The dismantling of the wall was soon followed by the collapse of the Soviet Union and the end of the Cold War. For forty years, the United States and the Soviet Union had competed for ideological, economic, and military dominance. Now that era was over. The United States stood alone as a military superpower. As the twentieth century drew to a close, the United States struggled to combat new threats and to redefine its role among the community of nations.

Operation Desert Storm

When Iraq invaded neighboring Kuwait in 1990, the United States, with the full support of the United Nations, resolved to liberate the tiny, oil-rich country. Over the next six months, President George H. W. Bush assembled an international coalition of more than thirty nations that included Egypt, France, Germany, Great Britain, Saudi Arabia, and Syria. Military leaders amassed troops and materiel, constructed bases, and targeted Iraqi military command centers and critical infrastructures. On January 17, 1991, coalition forces launched a five-week air assault, followed by a ground campaign that freed Kuwait in little more than a hundred hours.

One U.S. Air Force F-117 "stealth fighter" pilot described the opening attacks over Baghdad this way: "Ten minutes into Iraq there were huge explosions. My jet was getting bounced around at twenty-six-thousand feet. Then you see Baghdad. It was a fire-breathing dragon! Thousands of AAA pieces were firing. From thirty minutes out you could see it. It never stopped." After the initial air assault, ground troops joined the attack. Then, in little more than a hundred hours, the combined air-ground campaign freed Kuwait.

U.S. Commanders

America's military leaders were determined that Iraq would not be another Vietnam. Joint Chiefs
of Staff Chairman General Colin Powell ensured that the coalition used what he called "over-
whelming force." He also granted the coalition's commander, General Norman Schwarzkopf,
wide latitude to direct operations from the field.

Support for the Troops

Half a million American men and women were deployed in the Gulf War; 148 died in combat.
The speedy victory boosted public opinion of U.S. military prowess and public appreciation for
the nation's all-volunteer armed forces. Troops returned home to flag-waving crowds and an
outpouring of goodwill.

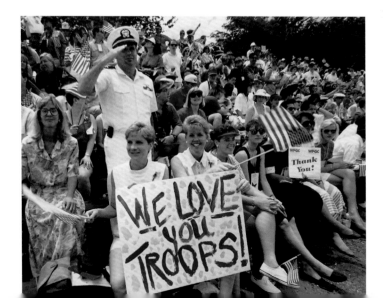

September 11, 2001

At 8:46 A.M. on September 11, 2001, terrorists hijacked and crashed a passenger jet into the north tower of New York City's World Trade Center. Fire and rescue crews rushed to the scene. As live television coverage began, Americans watched in horror as a second plane slammed into the south tower at 9:03 A.M. Thirty-five minutes later a third airliner dove into the Pentagon right outside the capital. A fourth jet bound for Washington, D.C., crashed in Pennsylvania, its hijackers probably thwarted by passengers. The nation reeled but resolved to fight back. These surprise attacks by al-Qaeda, an international Islamist terrorist group, killed three thousand people and launched an American-led war on terrorism.

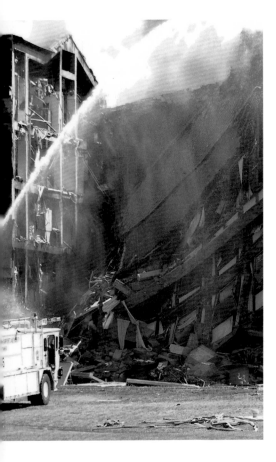

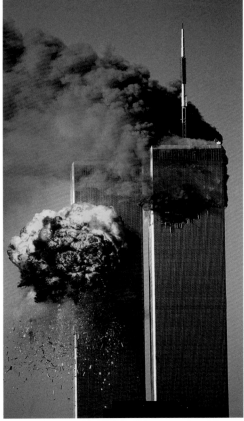

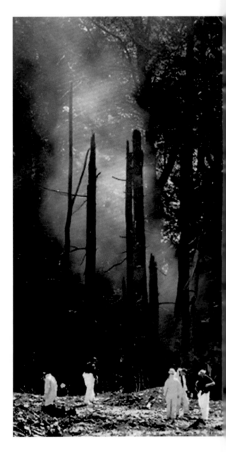

Operation Enduring Freedom

I n the aftermath of the September 11 attacks, the United States launched a war on terrorism using diplomacy, intelligence gathering and analysis, law enforcement, and monetary curbs. Having determined al-Qaeda's culpability, the United States directed its military force toward Afghanistan, where the ruling Taliban government was harboring al-Qaeda and its leader, Osama bin Laden.

In October 2001, allied forces launched a torrent of precision-guided bombs and sea-launched cruise missiles against targets in Afghanistan. Several hundred Central Intelligence Agency and Special Forces operatives, armed with bundles of cash, recruited anti-Taliban forces and joined them in ground fighting, directing air support with lasers and Global Positioning System devices. Taliban and al-Qaeda strongholds were quickly destroyed, but bin Laden and other highly sought leaders escaped.

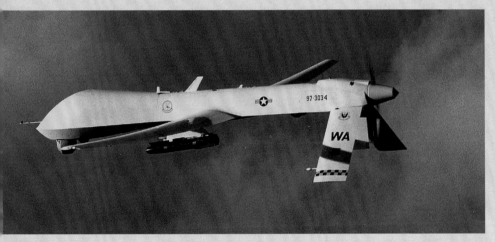

TOP
As the United States launched its attacks in Afghanistan, it simultaneously began a massive humanitarian relief operation. Millions of rations and explanatory fliers were air-dropped. Tons of supplies, from building materials to radios, were distributed on the ground. Troops were deployed to help Afghans build and rebuild schools and housing.

CENTER
Remote-controlled, unmanned aerial vehicles were widely used in Afghanistan. They carried cameras and sensors that provided real-time intelligence to field commanders around the globe. Armed with Hellfire-C laser-guided missiles, the drones attacked mobile targets.

BOTTOM
In Afghanistan, U.S. military forces experimented for the first time with various remote-controlled robots for ground reconnaissance. "Packbots" carried cameras that enabled ground troops to explore compounds and caves from a safe distance.

Operation Iraqi Freedom

In March 2003, the United States, Great Britain, and other coalition forces attacked and overthrew Saddam Hussein's brutal regime in Iraq. During the war, U.S. and coalition forces simultaneously employed air strikes of unprecedented precision and ground attacks that were fewer, faster, and more flexible than those of the 1991 Gulf War. Troops deployed through Kuwait raced three hundred miles to Baghdad, while Special Forces operatives were inserted deep into northern and western Iraq. Journalists embedded with the troops broadcast live reports to a global audience. Major combat operations took fewer than two months, but coalition units remained entangled in a controversial effort to establish an Iraqi democracy.

U.S.–Peshmerga Alliance

When Turkey refused to allow a major coalition offensive to cross its border, small numbers of U.S. Special Operations Forces were inserted into northern Iraq, where they mobilized Peshmerga, local Kurdish militia units. Kurds, a long-oppressed ethnic minority, were willing allies in the fight against Hussein.

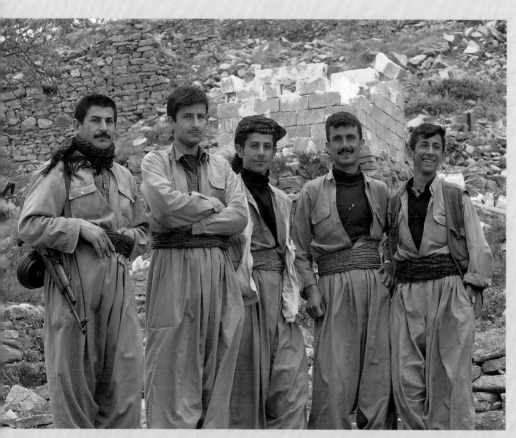

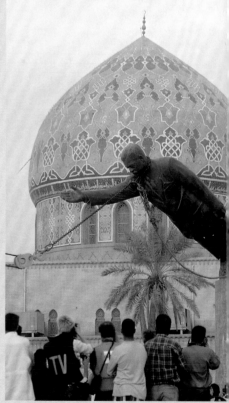

BELOW

Twenty-seven-year-old U.S. Army Ranger Captain Russell Rippetoe, killed on April 3, 2003, was the first casualty of the Iraqi war to be buried at Arlington National Cemetery. The bayonet worn by Rippetoe in Iraq, carried on the front of his uniform as seen here, was the same one used by his father during the Vietnam War.

Captain Rippetoe's Gold Star flag.

U.S. Casualties

U.S. forces suffered 139 combat-related deaths before "major combat operations" in Iraq ended on May 1, 2003. American and Iraqi authorities struggled to establish a functional interim government until national elections could be held. Although many Iraqis welcomed the outcome of the war, U.S. and coalition forces also faced civil unrest and an antioccupation insurgency. Hundreds more U.S. and allied troops were killed and wounded during subsequent operations.

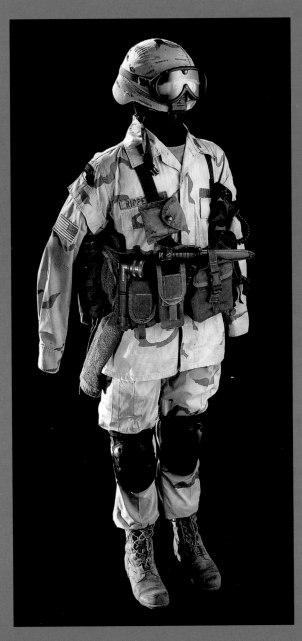

The Medal of Honor

The Medal of Honor is the nation's highest award for valor in combat. It recognizes individual gallantry at the risk of life, above and beyond the call of duty. It is customarily presented by the president of the United States in the name of Congress. To date, it has been granted to fewer than thirty-five hundred servicemen.

Each of the three principal services has a unique design for its medal. The army and navy awards center on the figure of Minerva, Roman goddess of war and wisdom. The air force award features the head of the Statue of Liberty. The look of today's navy medal is closest to the original medals of the Civil War era; the other two have twentieth-century designs. The neck ribbon for all medals includes thirteen stars, symbolizing the thirteen original states of the Union.

ABOVE

The Medal of Honor of Private Francis Brownell, who was awarded the medal for the first deed in the Civil War to be so recognized.

LEFT

U.S. Army, Air Force, and Navy Medals of Honor.

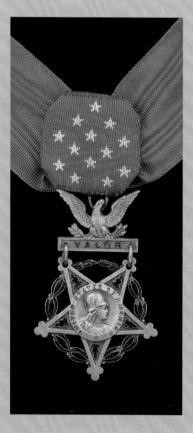 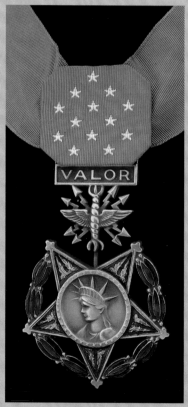 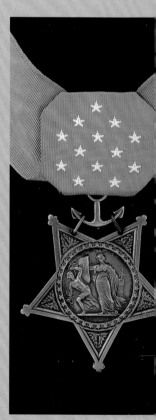

Military Honor Guard.

History of the Medal

In the early days of the Civil War, Congress established the Medal of Honor first for the navy and then for the army. Criteria for the award were lax then, and nominations required little review. More than twenty-four hundred medals were eventually granted for Civil War service, although more than nine hundred of them were later revoked. By the early twentieth century, requirements were more stringent. Between 1918 and 1963, the medal was restricted to well-documented and carefully reviewed acts of distinguished service. In 1963, a further provision limited the award to heroism in combat.

EXHIBITION TEAM

David Allison, Project Director and Exhibition Curator
Ann Burrola, Project Coordinator
Lynn Chase, Project Manager
Dik Daso, Exhibition Curator
Stevan Fisher, Exhibition Design Manager
Julia Forbes, Exhibition Educator
Jane Fortune, Collections Manager
Kathy Golden, Collections Manager
Barton Hacker, Exhibition Curator
Jennifer Jones, Artifact Curator
Laura Kreiss, Photo Editor
Laurel Macondray, Photo Editor
Joan Mentzer, Technical Editor
David Miller, Collections Manager
Howard Morrison, Exhibition Curator

The Price of Freedom: Americans at War exhibition web page may be accessed at: www.americanhistory.si.edu/militaryhistory

The web page includes exhibition script, artifact descriptions, maps, images, and personal stories. In addition, the museum has published a teacher's manual for grades 5–12, with lesson plans and an accompanying DVD. Contact the museum to obtain a copy or look for an electronic version at the website.

IMAGE CREDITS

Air Force Association: 88 (center)
AP/Wide World Photos: 69 (bottom left), 72, 80–81 (background), 82 (top), 88 (background), 91 (bottom), 92 (bottom right)
Appomattox Court House National Historical Park: 47 (top left)
Architect of the Capitol: 19 (top)
Chicago Historical Society: 35 (top right)
The Connecticut Historical Society, Hartford, Connecticut: 11 (top left and bottom)
Denver Public Library: 29 (top right)
© 1986 The Detroit Institute of Arts, Gift of Dexter M. Ferry, Jr.: 16 (top)
Courtesy of the Burton Historical Collection, Detroit Public Library: 47 (background)
Franklin D. Roosevelt Library: 59 (bottom left)
Gay Morris Collection: 62–63 (background)
Getty Images: 90 (left and center)
The Gilder Lehrman Collection, on deposit at the New York Historical Society, New York: 42 (right)
Greg Mathieson: 92 (bottom left)
Harry S. Truman Library: 70 (bottom left), 76 (bottom left)
Independence National Historical Park: 12 (top left), 15 (bottom right)
The John Carter Brown Library at Brown University: 18 (left)
Library of Congress: 6–7, 10 (left and right), 13 (top), 14 (bottom), 16 (bottom), 20–21, 22 (bottom), 23 (top left), 25 (bottom right), 29 (bottom right), 30 (left), 32–33, 34 (center), 35 (top left), 36 (bottom), 37 (top right and background), 38 (right), 40 (bottom right), 46 (top left and bottom), 48 (bottom right), 49 (bottom left and right), 53 (bottom left), 79 (middle center right)
Magnum: 81 (bottom)
Museum of the Confederacy, Richmond, Virginia: 35 (center and bottom left)
National Air and Space Museum, Smithsonian Institution: 75 (all), 77 (left), 78 (top left), 80 (left), 91 (center), 94 (bottom left, center, and right)
National Anthropological Archives, National Museum of Natural History, Smithsonian Institution: 28–29 (background)
National Archives: 12 (bottom and background), 17 (right), 27 (top right and bottom left), 30 (right), 46 (background), 47 (top right), 48 (bottom left), 50, 51, 52 (bottom left), 53 (top left and center), 56 (top left, center, and bottom), 57 (top right and center), 58 (bottom right and background), 60 (right), 62 (bottom left and right), 63 (bottom right), 64 (bottom), 65 (top right and bottom left), 66 (all), 67 (bottom left), 68 (all), 69 (top right and background), 70 (top left, bottom right, and background), 71 (bottom left and background), 72–73 (background), 74, 76 (bottom right and background), 77 (right), 78 (bottom left and right), 79 (middle left, center left, right, bottom center and right), 80 (right), 82 (bottom), 84 (bottom left)
National Museum of American History, Smithsonian Institution: 23 (bottom right), 26 (top), 31 (top right), 34 (top left), 37 (top left), 40 (top right), 41 (top left and bottom right), 43 (bottom left and right), 48 (top left and center), 53 (right), 55 (all), 59 (bottom right), 61 (all), 63 (bottom left), 83, 85 (all), 89 (top right and bottom), 95
National Museum of Health and Medicine: 38 (left and center)
National Portrait Gallery, Smithsonian Institution: 15 (top right), 34 (top right and bottom left), 42 (left)
Pennsylvania State Archives, RG-25 Records of Special Commissions: 49 (top right)
Reuters: 90 (right)
Ronald Reagan Library: 86–87
Smithsonian Libraries: 43 (top), 44 (top left and right)
University of Michigan, William L. Clements Library: 24
Wisconsin Historical Society: 9

Library of Congress Control Number: 2004113406

ISBN 0-9744202-3-9

Published by
Smithsonian Institution,
National Museum of American History,
Behring Center

in association with

Marquand Books, Inc., Seattle
www.marquand.com

Distributed by
University of Oklahoma Press
1005 Asp Avenue
Norman, OK 73019

Front cover: Detail of service flag. When displayed, the flag indicates a family member in military service.
Back cover: Images representing the scope of the Price of Freedom exhibition.
Flap interiors: Women flyers, World War II (front), and the Tomb of the Unknowns, Arlington (back).

Smithsonian Photo Staff: Mark Avino, Harold Dorwin, Heidi Fancher, Joe Goulait, Eric Long, Richard Strauss, Hugh Talman, Jeff Tinsley
Edited by Dik A. Daso, Curator of Modern Military Aircraft, National Air and Space Museum, Smithsonian Institution
Text by Howard Morrison, David Allison, and Dik Daso
Copyedited by Amy Smith Bell
Proofread by Laura Iwasaki
Designed by Jeff Wincapaw with assistance by Andrea Thomas and Zach Hooker
Color separations by iocolor, Seattle
Printed and bound by C&C Offset Printing Co., Ltd., China